Valerie O'Sullivan

Inner Thoughts

Reflections of Contemporary Irish Women

VERITAS

First published 1999 by
Veritas Publications
7/8 Lower Abbey Street
Dublin 1

ISBN 1 85390 448 1

The author would like to thank the following people for their help and support:
Ger O'Sullivan, IT Support;
Michael Mac Sweeney, Provision Photo Agency, Cork;
Richard Mills, Paddy Barker and Pat Good, Photographic Department, Examiner Publications;
The staff at Veritas Publications;
To all my family and friends, your support and encouragement will always be appreciated.

Designed by Colette Dower
Cover photograph by Valerie O'Sullivan: 'Against the wind and sea' – Anne Herbert, a full-time performer with Siamsa Tíre,
the National Folk Theatre, Tralee, is pictured on Banna Strand, County Kerry.
Back cover flap photograph by Richard Mills, Examiner Publications
Printed in the Republic of Ireland by Betaprint Ltd, Dublin

Contributors

Gemma McCrohan, 6

Maxi, 8

Niamh Murray, 10

Sarah Flannery, 12

Maria Simmonds Gooding, 14

Sinéad O'Mahony, 16

Garry Hynes, 18

Ellen Byrne, 20

Rev Lynda Peilow, 22

Éilis Ní Dhuibhne, 24

Donna Daly-Blyth, 26

Mary Ennis, 28

Peggy Morgan, 30

Mary Banotti, 32

Jackie McKenna, 34

Dervilla Keating, 36

Mary Leonard, 38

Darina Allen, 40

Margaret Kenny, 42

Alice Taylor, 44

Elaine O'Donovan, 46

Mary Lee-Stapleton, 48

Bernadette Greevy, 50

Marie Foley, 52

Ruth Gill, 54

Breda Joy, 56

Nicola Underwood-Quinn, 58

Eileen Good, 60

Aileen O'Sullivan, 62

Geraldine Lake, 64

Margaret Hickey, 66

Caroline Mooney, 68

Ursula O'Farrell, 70

Fiona Moriarty, 72

Ruby Barber, 74

Sr Thérèse Murphy, 76

Edel Sutton, 80

Padraigín Clancy, 82

Bridget Delaney, 84

Mother Agnes Griffin, 86

Sr John Francis Watson, 86

Lorna Siggins, 90

Breda Marnane, 92

Kathleen Mahon, 94

Nuala Ní Dhomhnaill, 96

Geraldine Byrne, 98

Angela White, 100

Judy Greene, 102

Valerie Jones, 104

The Nualas, 106

Claire Troy, 108

Adi Roche, 110

Patricia Darling, 112

Maureen Dillon, 114

Neasa O'Riordan, 116

Geraldine Hurley, 118

Teresa McMorrow, 120

Sr Thérèse Larkin, 122

Robbie McKeown, 124

Loraine Devlin, 126

Frances Lynch, 128

Mary McKenna, 130

Nóirín Ní Riain, 132

Foreword

It was an honour to be asked to write a foreword to this beautiful book. Reading the contributions of these strong, enlightened, very spiritually aware women was an empowering experience.

In today's frantic, fast-paced, material world, it is easy to lose sight of our essence. Our true spirit. We can all relate to the harried mother on the way home from work to collect her children from the crèche, stuck in gridlock; the social worker listening to stories of harrowing despair and deprivation; the nurse, underpaid and undervalued, trying to give her best to the sick and dying; the teacher trying to teach and maintain discipline in classrooms where boundaries have disappeared and respect is non-existent; the carer trying to look after an elderly relative or spouse. Stress and hassle is the norm.

To try and tap into that inner place of calmness and serenity where our souls connect with our spirit can sometimes be well nigh impossible. Every day we are bombarded with negativity. Switch on the news, read the papers – our world is in turmoil with wars, famines, earthquakes. We are poisoning our planet. Human beings are inflicting unspeakable suffering on other human beings.

As long as we are disconnected from our spirit we will never be peaceful. But when we make that connection, how wonderful it is. We come home to ourselves and renew and revive our true spirit in a way that is incomparable. The more we open to this real, essential part of us, the more we get back in return.

I have an eight-month-old niece who is joy and love personified. To her, each day is a great new adventure. Everyone is greeted with a wide, trusting smile. Everything is viewed with eager curiosity and delight, a golden leaf floating down into her pram, a bird singing his heart out, the washing machine spinning madly, her first taste of banana and pear. So much to see and touch and taste. She has taught me to look at the world with new eyes, to see the beauty that is there, and in that beauty to make my own joyful connection with my true spirit.

I hope this book helps you to do the same. Have a truly wonderful, spiritual millennium.

Patricia Scanlan

GEMMA McCROHAN

Gemma McCrohan is a reporter with RTÉ's very successful television programme Would You Believe, *now in its eighth year. The programme deals with social and political justice and how people's lives are influenced by their faith or lack of it. Gemma's radio series* The Sad, The Mad and The Bad, *with Martha McCarron, won them a Jacob's Award. Gemma began her career as a primary school teacher and started in television in 1988 with a series called* Hard Times, *which dealt with the effects of unemployment. She is married to Jimmy McCrohan, and they have three children. Gemma enjoys theatre, cinema and the company of friends.*

'I have great difficulty with prayer. Do you know that Nick Cave song, "I don't believe in an interventionist God…"? Well, that about sums me up. I have memories of praying for success in exams, knowing that I had an awful cheek because I hadn't worked. I can't conceive of a God who is involved with such matters anyway. Why should he be concerned about such petty things when maybe a landslide has wiped out a thousand people in Peru or somewhere?

I remember, when I was about thirteen, a nun told us we should say the *Memorare* every night for purity. I had only a hazy notion of what purity was all about, it was somehow bound up in heroism and Maria Goretti and being willing to die. I duly said a *Memorare* for purity every night for about seven years. I said thousands of them. I was deeply disappointed when I found that I didn't have a kind of impenetrable force-field around me that would protect me from temptation. Now when I look at the words of the *Memorare*, "O Virgins of Virgins, my Mother", I find it very difficult to relate to – as a positively unvirginal mother.

When I'm in difficulties, terrified or worried, of course I pray – the way I'm sure even an atheist prays, but it's a kind of instinctive cry for help. And I'm glad when someone tells me they will pray for me. I remember the Catechism definition for prayer: "Lifting the mind and heart to God". I can experience that with Psalm 23 "The Lord is my Shepherd", but also with what I feel is a modern equivalent: *Bridge Over Troubled Waters* by Simon and Garfunkel. It may be written from a secular viewpoint but I find it very inspiring. I can also get a sense of the numinous when I listen to certain pieces of music. Fauré's *Requiem* is filled with a sense of God, and Rachmaninov's *Vespers*, sung by a Russian choir, would move a stone.'

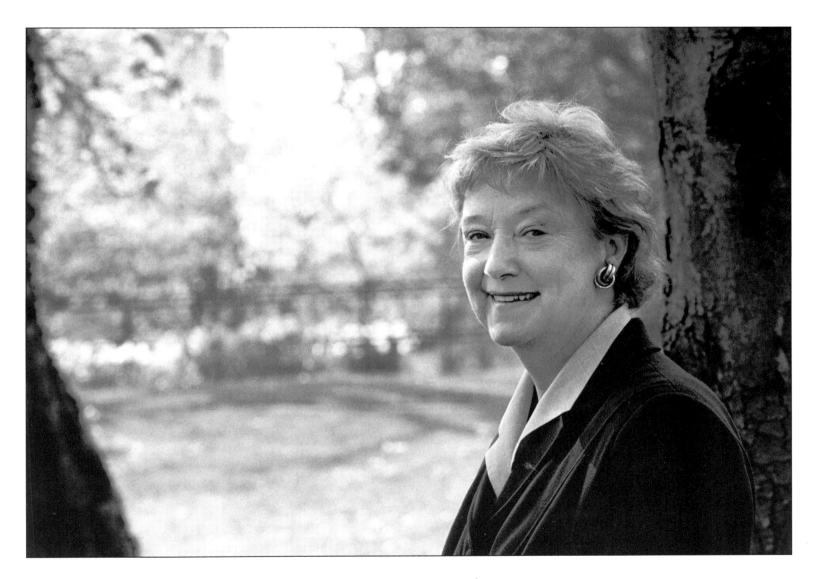

Gemma McCrohan is pictured outside the RTÉ studios in Donnybrook.

MAXI

Maxi is a presenter/producer at RTÉ Radio Centre, where she produces the popular Risin' Time *and* Late Date *programmes. She also writes the informative 'Turning Point' in the* RTÉ Guide. *Maxi began her career as part of a three girl group 'Maxi Dick and Twink' formed by the late Eamon Andrews. She then joined the very successful trio 'Sheeba', who represented Ireland in the Eurovision Song Contest. Maxi also represented Holland in the World Song Contest in Tokyo. She was the first female game show presenter in Ireland, presenting* Rapid Roulette. *Other successes include* The Den *with* Zig and Zag, *Eurosong,* Live Aid *and* The Live Lotto Draw. *Maxi also signalled the start of 24-hour broadcasting on RTÉ Radio One.*

> Dear God
> Thank you for sending me people who annoy me
> They drive me crackers, but they do teach me not to react.
> They strengthen me by teaching me to transmute negative energy into
> positive energy
> Using them, I will convert irritation and hatred to passivity and love.
> Thank you for allowing me this journey on your earth plane.
> It's an incredible experience.
> Thank you for life, annoyances, and for teaching me through them, free of charge.

'This reflection serves me well in the everyday working world, when I'm chasing deadlines and running against the clock and all of a sudden I meet with someone I'd like to beam up to anywhere but here. I hope it helps someone else as much as it continually helps me.'

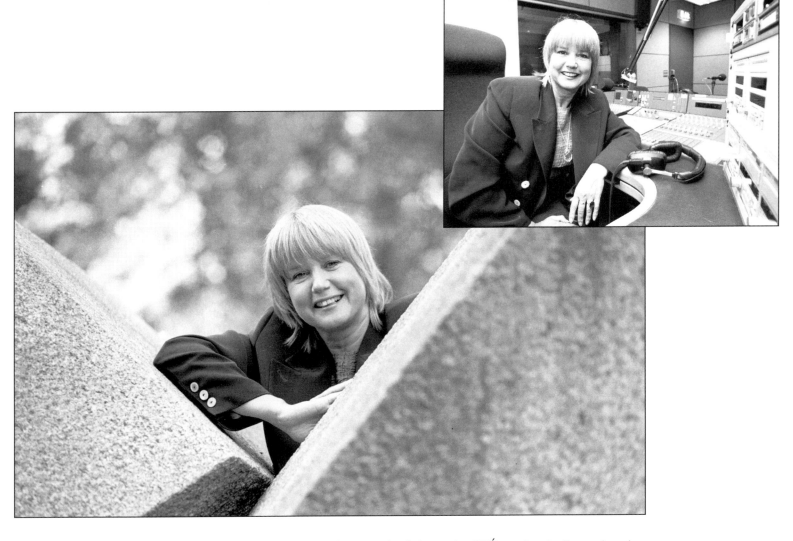

Maxi takes a break from her hectic schedule at the RTÉ studios in Donnybrook.

NIAMH MURRAY

Niamh Murray is regarded as one of Ireland's finest sopranos. She studied music at the Royal Academy of Music, Dublin, the Leinster School of Music and the Northern College of Music, Manchester. Niamh is a qualified school teacher, and has a licentiate in speech and drama and a diploma in public relations. Encompassing roles in operas, operettas and musicals, Niamh performs regularly at the National Concert Hall. She is a guest presenter on Lyric FM. She featured on BBC's Songs of Praise which was broadcast from Rome during Easter 1997. She was also guest soloist in the Pioneer Centenary Mass in Croke Park. She has recorded many albums which include, A Fairer Paradise, When Irish Eyes are Smiling, Wedding Memories from Ireland *and* Best Loved Sacred Music. *She is also the leading lady at Jury's Cabaret. Niamh lives in Dublin and enjoys golfing, swimming and reading.*

Pioneer Offering Prayer
For the greater glory and consolation
O Sacred Heart of Jesus!
for the sake to give good example,
to practice self denial,
to make reparation to Thee for the sins of intemperance
and for the conversion of excessive drinkers,
I will abstain for life from all intoxicating drinks.

'As a pioneer I say this prayer for the excessive abusers of alcohol and their families.'

'The world of entertainment can be a very shallow and critical one. I constantly strive to do my best, no matter how many times I fail. I am very conscious of having regard and respect for my fellow artistes. Also, I am very close to my parents, Ciarán and Mena, who epitomise for me the words of the First Letter of St Paul to the Corinthiains (12:31-13:8).'

But strive for the greater gifts. And I will show you a still more excellent way. If I speak in the tongues of mortals and of angels, but do not have love, I am a noisy gong or a clanging cymbal. And if I have prophetic powers, and understand all mysteries and all knowledge, and if I have all faith, so as to remove mountains, but do not have love, I am nothing. If I give away all my possessions, and if I hand over my body so that I may boast, but do not have love, I gain nothing. Love is patient; love is kind; love is not envious or boastful or arrogant or rude. It does not insist on its own way; it is not irritable or resentful; it does not rejoice in wrongdoing, but rejoices in the truth. It bears all things, believes all things, hopes all things, endures all things. Love never ends.

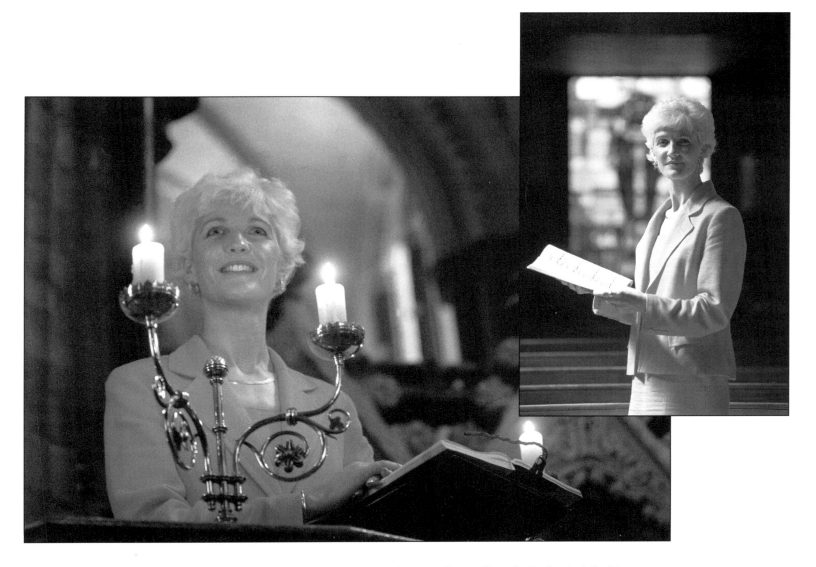

Main picture of Niamh Murray is taken in Christ Church Cathedral, Dublin.

SARAH FLANNERY

Sarah Flannery, aged seventeen, won the Esat Young Scientist of the Year Award in January 1999 with her project on an encoding system for electronic information entitled 'Cryptography – A New Algorithm vs the RSA which deals with Cryptography – The Science of Secrecy'. She also won first prize at the 11th European Union Contest for Young Scientists in September 1999. Meanwhile, Sarah is a student at Scoil Mhuire gan Smal in Blarney. Her hobbies include basketball, gaelic football, showjumping, karate and reading. She lives with her parents, Dave and Elaine, and her brothers.

'My great-grandmother Lizzie Counihan's life spanned almost the entire twentieth century. When she died recently, at the age of ninety, the gathering at her funeral was larger that any I had ever seen. Her family and friends were there not under obligation or out of courtesy but because she had loved them and they her. I hope that one day I too will be as deserving as she of such a tribute to my own life.'

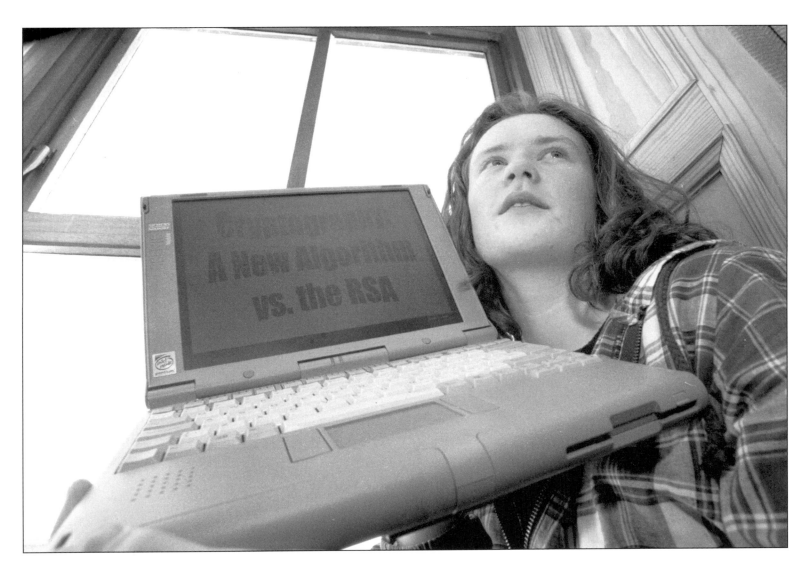

The world's media descended on Sarah Flannery at her home after she won the Young Scientist of the Year Award.

MARIA SIMONDS-GOODING

Maria Simonds-Gooding is an artist. She was born in India and has lived in Kerry since 1947. Her work has been exhibited in Dublin, New York, Brussels, New Mexico and London. Her art form is primitive, and is inspired by the starkness of the landscape and the intensity of the light in Dun Chaoin, County Kerry, where she has lived since 1968. Her work is best described using two of her etchings:

'Down by the Lake' 'The Lake by the Bog'

'The earth around the world has been used for vegetation, and also for burial and ceremonial purposes. Tribal people almost always place the centre of their spirituality and religion in a deep reverence for nature. My work is about land, and man's relationship to it, whether it be in Ireland or other parts of the world. In remote places you will find the farmer and the shepherd have a particularly intimate relationship with their environment, challenging the elements and using the land in many different ways for the protection of their crops and animals.'

Lord Jesus Christ have mercy on me.

'I first came to know the Jesus prayer in a monastery of eighteen monks in the Sinai Desert. Walking the mountains of Sinai was perhaps the greatest prayer of all. But the Jesus prayer is my favourite prayer. Repeated in the form of a meditation, it is just as natural as breathing.'

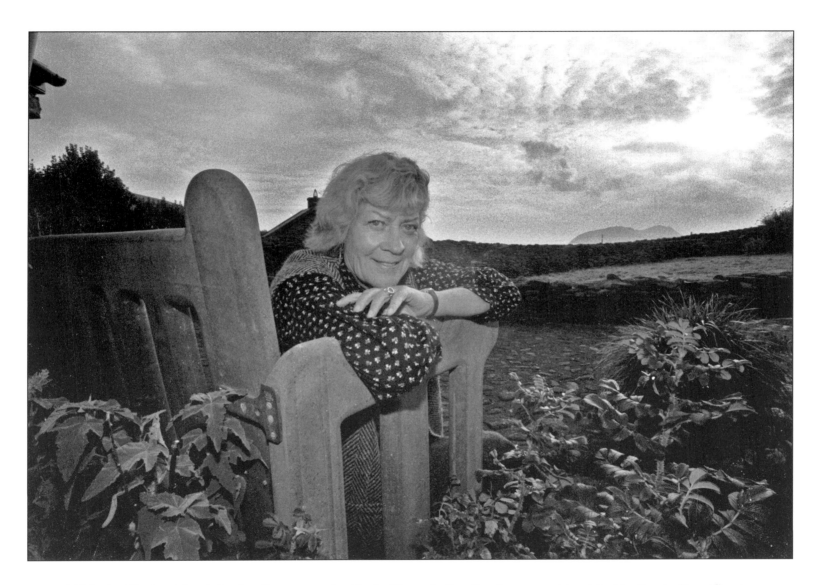

With the Blasket Islands in the distance, artist Maria Simonds-Gooding is never without inspiration in Dun Chaoin.

SINÉAD O'MAHONY

Sinéad O'Mahony is a community youth worker with Cashel & Emly Youth Service, County Tipperary. She works with young people from the ages of eight to eighteen years. Sinéad looks at the social needs of each one individually and then tries to 'tap them into something positive'.

Footprints
One night a man had a dream.
He dreamt he was walking along the beach with the LORD.
Across the sky flashed scenes from his life.
For each scene, he noticed two sets of footprints in the sand;
one belonging to him, and the other to the LORD.
When the last scene of his life flashed before him,
he looked back at the footprints in the sand.
He noticed that many times along the path of his life there was only one set of footprints.
He also noticed that it happened at the very lowest and saddest times in his life.

This really bothered him and he questioned the LORD about it.
'LORD, you said that once I decided to follow you, you'd walk with me all the way.
But I have noticed that during the most troublesome times in my life,
there is only one set of footprints.
I don't understand why when I needed you most you would leave me.'

The LORD replied, 'My precious child, I love you and I would never leave you.
During your times of trial and suffering,
when you see only one set of footprints in the sand,
it was then that I carried you.'

'Nobody wants to be alone, we need a sense of security. The simplicity of *Footprints* is universal. We are never alone.'

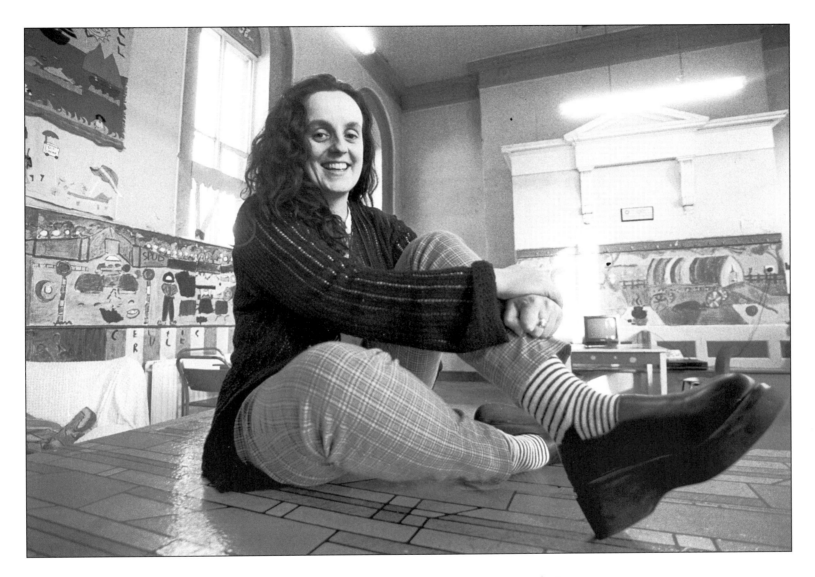

Sinéad O'Mahony takes a breather in Tipperary Youth Centre.

GARRY HYNES

Garry Hynes is one of the founders of the Druid Theatre Company in Galway. She has served as artistic director of the company between 1975 and 1990, and again since 1994. In 1990 Garry Hynes was appointed artistic director of the Abbey Theatre, Dublin. Her productions have included The Plough and the Stars *by Seán O'Casey and* The Power of Darkness *by John McGahern. In 1996 she directed* The Beauty Queen of Leenane *by Martin McDonagh, a Druid Theatre Company/Royal Court Co-production. The production moved to Broadway where it earned her a Tony Award for Directing – the first woman to receive such an award. Garry has also received two LLDs* (Honoris Causa), *both for outstanding service to Irish Theatre. In 1999 she directed* The Lonesome West *by Martin McDonagh, which opened on Broadway in April. Garry is a native of Ballaghadereen, County Roscommon.*

The Memorare
Remember, O most gracious Virgin Mary,
that never was it known
that anyone who fled to your protection,
implored your help
or sought your intercession
was left unaided.
Inspired with this confidence,
I fly to you,
O Virgin of Virgins, my Mother.
To you I come,
before you I stand,
sinful and sorrowful.
O Mother of the Word incarnate,
do not reject my petitions,
but graciously hear and answer them.
Amen.

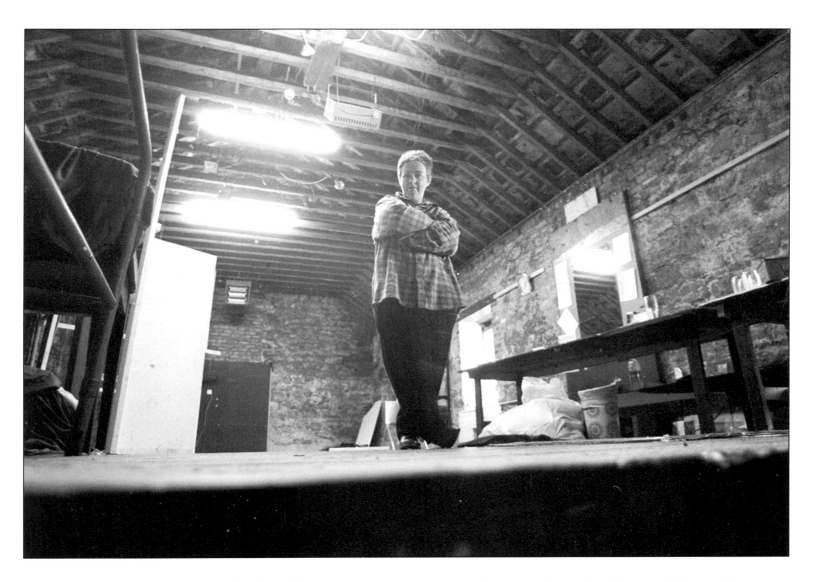

Garry Hynes is pictured in the Druid Theatre – a converted tea warehouse in the medieval heart of Galway City.

ELLEN BYRNE

Originally from Dublin, Ellen Byrne is a former Bunratty singer and accomplished musician. She is the press and publicity officer at the World Music Centre, University of Limerick. Her work involves creating an awareness of the centre and promoting its recitals, festivals and lunch-time concerts, as well as it's summer schools and post-graduate programmes. Ellen lives in Askeaton, County Limerick, with her husband Peter Dundon and their daughter Janie.

The Sunset Poem of Rev. Eli Jenkins
from 'Under Milkwood' by Dylan Thomas

Every Morning when I wake,
Dear Lord a little prayer I make.
Oh Please to keep thy lovely eye
On all poor creatures born to die.
And every evening at Sun-down
I ask a blessing on the town.
For whether we last the night or no
I'm sure is always touch and go.
We are not wholly bad or good
Who live our lives under Milkwood.
And thou I know will be the first
To see our best side, not our worst.
Oh let us see another day
Bless us this night I pray.
And to the sun we all will bow
And say goodbye, but just for now.

'I don't pray often, but I find this really moving. It's so simple but it covers everything, I think. Apart from being a beautiful piece of writing, it was a favourite prayer of my mother's. She was from Kilkee, County Clare – my spiritual home – a place we spent all our childhood summers. She had this framed on her bedroom wall and it was read at her funeral, so it holds a lot of associations for me. Dylan Thomas also happens to be a favourite writer of my husband's, so it's doubly special for that reason.'

Ellen Byrne is pictured at the Irish World Music Centre in the University of Limerick.

LYNDA PEILOW

Lynda Peilow has been the curate assistant at Castleknock, Mulhuddart and Clonsilla for three years. She was ordained deacon at St Brigid's Church, Castleknock in October 1997, and ordained a priest at Christ Church Cathedral, Dublin in September 1998. Her duties include leading worship on Sundays, visiting the sick at home and in hospital, presiding at the Eucharist and preaching at services. Lynda is chaplain to James Connolly Memorial Hospital and chaplain to Castleknock Community College.

Lord,
Make me a channel of your peace:
Where there is hatred, let me bring your love,
Where there is injury, your pardon Lord,
And where there's doubt, true faith in you:
Make me a channel of your peace:
Where there's despair in life let me bring hope,
Where there is darkness, only light,
And where there's sadness, ever joy:
O master grant that I may never seek
so much to be consoled as to console;
to be understood as to understand,
to be loved, as to love with all my soul.
Make me a channel of your peace:
It is in pardoning that we are pardoned,
In giving of ourselves that we receive,
And in dying that we are born to eternal life.

(source unknown, attributed to Francis of Assisi, 1181-1226, arrangement Sebastian Temple)

'On the day of my ordination I promised, with the help of God, to promote unity, peace and love among all Christian people, and to care for the sick, the poor and the needy. I also promised to fashion my own life according to the way of Christ. In all that I am and all that I do in life, I pray that I may be a channel through which God can work.'

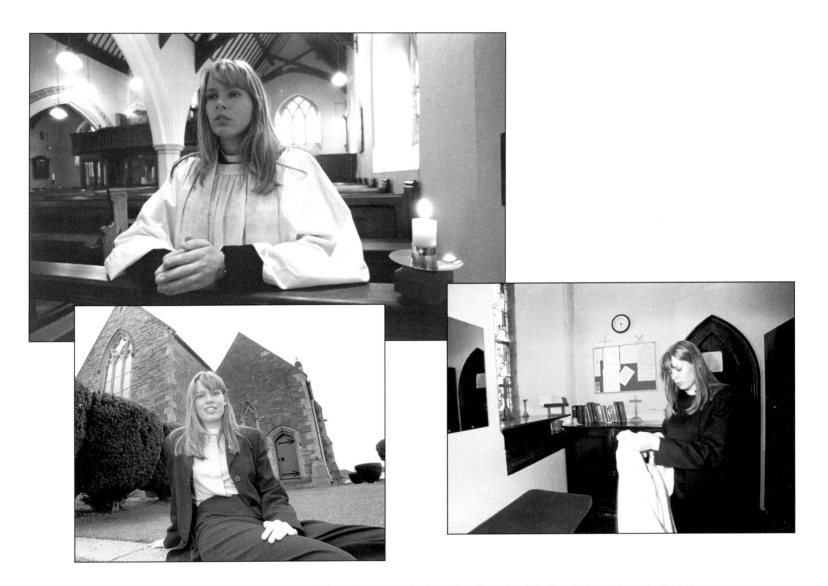

Lynda Peilow carries out some of her duties at St Brigid's Church of Ireland, Castleknock, Dublin.

ÉILÍS NÍ DHUIBHNE

Éilís Ní Dhuibhne is the assistant manuscript keeper at the National Library of Ireland. She is a folklorist and former teacher. An accomplished author, she has written The Bray House, The Hiring Fair, The Island Ice, *and, most recently,* The Dancers Dancing *(Blackstaff Press, 1999). Éilís's work deals sensitively with issues of cultural identity, language and Irish society. She is married to Bo Almqvist (a Lutheran Protestant from Sweden — former Professor of Irish Folklore at University College, Dublin). They have two sons, Ragnar and Olar, both in their teens. A native of Dublin, Éilís and her family live in Shankill, County Dublin.*

'I pray that I become kinder and more honest as I journey through my life;
that people everywhere try to understand and respect beliefs
and attitudes that are different from their own;
that compassion is honoured as the greatest virtue;
that the natural world be treated with respect and kindness, managed with skill and
understanding, so that it survives for our children and future generations;
that my husband and children stay strong and healthy and happy;
also I pray that I write at least one good book – soon.'

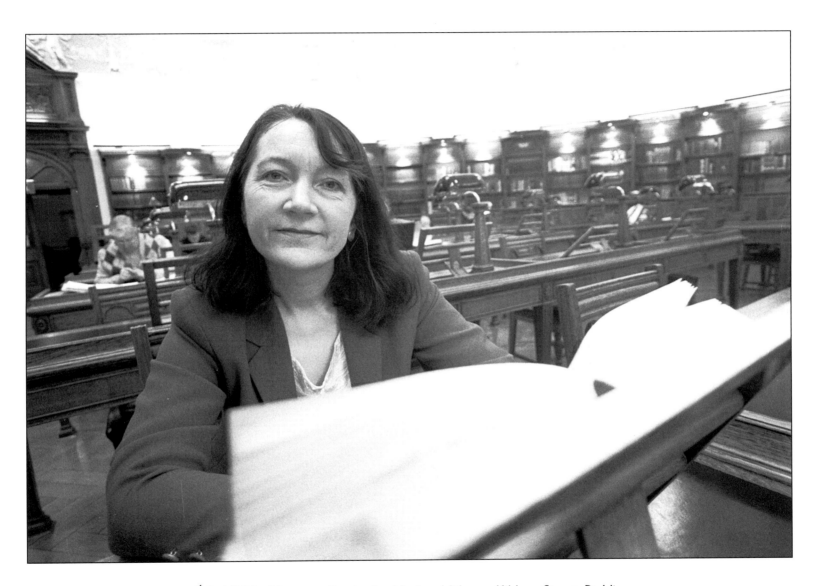

Éilís Ní Dhuibhne reading in the National Library, Kildare Street, Dublin.

DONNA DALY-BLYTH

Donna Daly-Blyth is the course director in Dance and Arts Performance at Coláiste Stíofain Naofa at the Firkin Crane in Cork. Donna's formal training began with Eileen Kavanagh and with the Joan Denise Moriarty School of Dance, both in Cork City. She pursued a career in dance, particularly dance for the theatre, and is at the forefront of dance policy, development and training in Ireland. She is married to Aengus and they have two teenage children, Meghan and Dominic.

> God,
> grant me the Serenity
> to accept the things
> I cannot change,
> the Courage to change
> the things I can,
> and the Wisdom
> to know the difference.

'Serenity, courage and wisdom – I can equate the art of dance into each of them. Serenity, for me, is when I have an open space, and my own body dancing enables me to find my own serenity, which most people long to find in their lives. Courage, for me, is the courage to criticise your body in front of a mirror every day, to bear that pain for every day you want to dance. Wisdom is the combination of the first two. Happiness, for me, is unrelated to material and commercial success – to be truly happy, you have to be happy within yourself.'

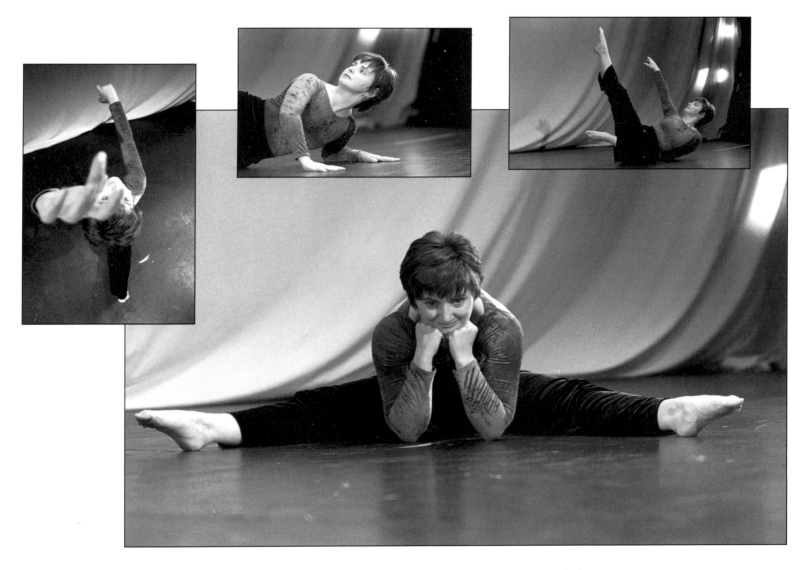

Donna Daly-Blyth practices at the Firkin Crane Theatre, Cork.

MARY ENNIS

Mary Ennis was born and raised in the Liberties in the heart of Dublin City. Before she retired she worked as a cleaner in the Department of Foreign Affairs. She is a regular Mass-goer at Meath Street Church.

Sacred Heart of Jesus,
I place all my trust in thee.

'I pray to the Sacred Heart and Our Lady all the time. I pray for my children, grandchildren and great-grandchildren. I pray the Rosary every day in honour of Our Lady in Heaven.'

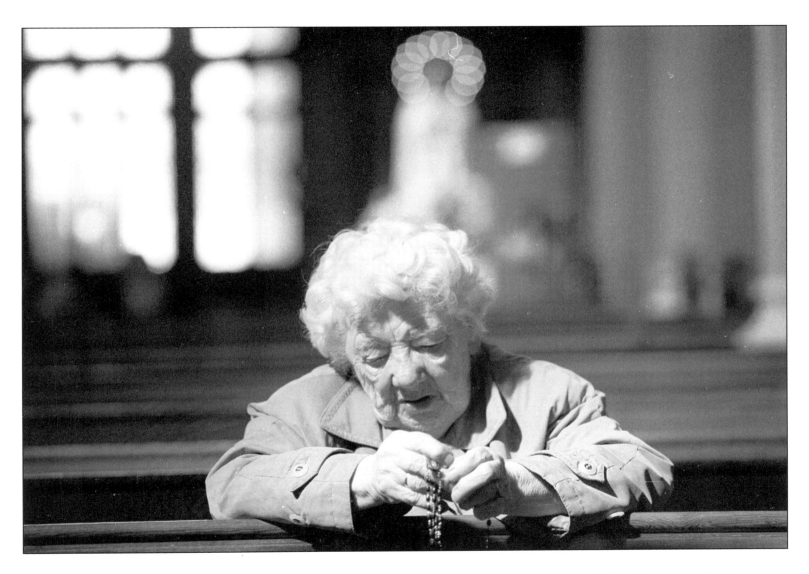

Mary Ennis prays after morning Mass in the parish church in Meath Street, the heart of The Liberties in Dublin.

PEGGY MORGAN

Peggy Morgan is from Blainmore, Kilrush. She works in Considine's Bakery, Kilrush, which is over 150 years old. Peggy has worked in the bakery for twenty-one years, and has built up an enormous rapport with the customers and visitors. Peggy's duties at the bakery include slicing, wrapping and labelling each loaf. She is very proud of her work and the bakery.

> Lord Jesus,
> I give you my hands to do your work,
> I give you my feet to go your way,
> I give you my eyes to see as you see,
> I give you my tongue to speak your words,
> I give you my mind that you many think in me.

'Work is a prayer – being friendly with people, making time for them. A good laugh is a tonic. Our love for people reveals God's love for us.'

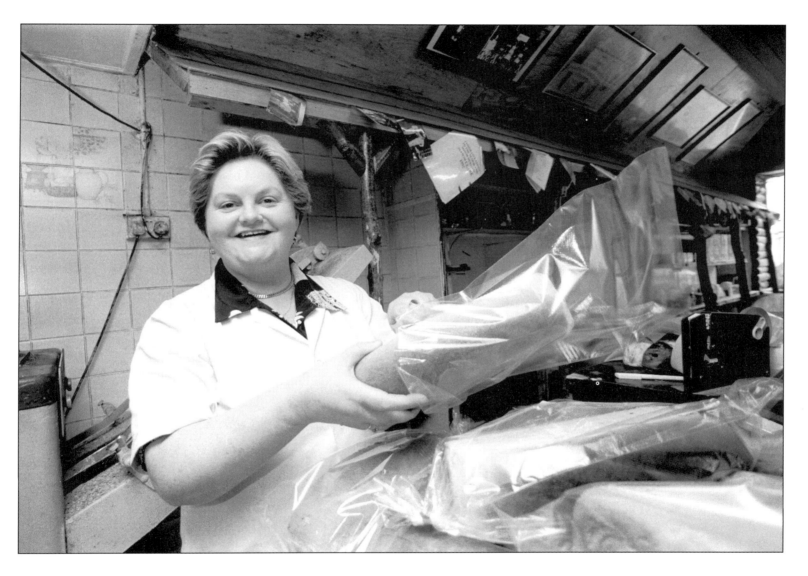

Peggy Morgan packs the first batch of bread in Considine's Bakery, Kilrush.

MARY BANOTTI

Mary Banotti is a full-time public representative for Dublin in the European Parliament (1984, 1989, 1994 and 1999). Before her career in politics Mary worked as a nurse in the USA, Canada, England, Italy and Africa. She has been appointed by successive presidents of the European Parliament as their special mediator for abducted children. In the past two years, Mary has successfully dealt with over thirty-two cases of child abduction throughout Europe, the United States and North Africa. She was the Fine Gael Presidential Candidate in 1997 and, also in that year, was selected European of the Year. Following her re-election to the European Parliament in June 1999, Mary Banotti was elected by an overwhelming vote as Quaestor of the Parliament. She is the grand-niece of Michael Collins and has one daughter, Tania.

Hail Mary, full of grace,
The Lord is with thee.
Blessed art thou amongst women
and blessed is the fruit of thy womb, Jesus.
Holy Mary, mother of God,
pray for us sinners,
now, and at the hour of our death.
Amen.

'The *Hail Mary* was the first prayer I ever learnt, and in times of need, it is the first prayer that comes into my head, probably for that reason. It has a comforting familiarity and is like a mantra, which is essentially a short repetitive incantation. When asked for a prayer I thought about many other beautiful prayers and incantations but, in fact, kept coming back to the *Hail Mary.*'

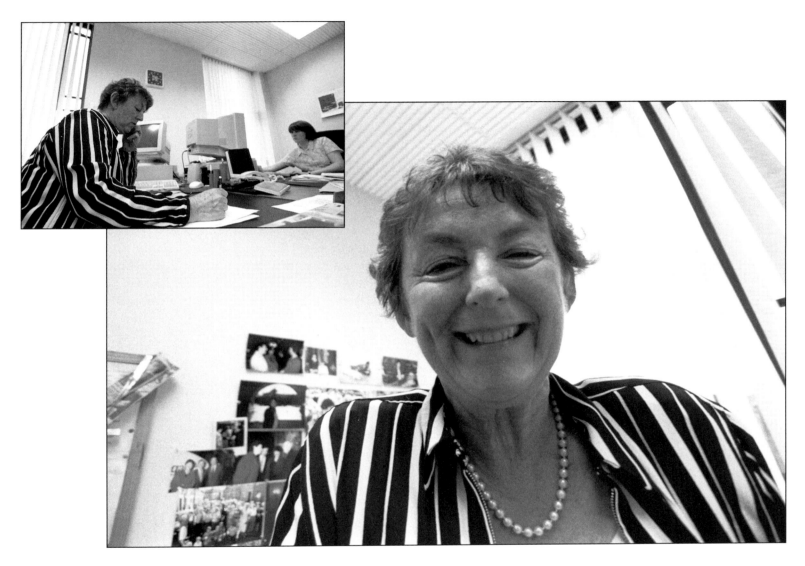

MEP Mary Banotti gets down to the business of the day. Also pictured is team member Geraldine Flood.

JACKIE MCKENNA

Jackie McKenna has been a prison officer in the female section of Mountjoy Prison for nine years. Jackie is the supervising officer in charge of shoe-making in the prison. She is also the relief medical orderly.

Agnus Dei
Lamb of God, you take away the sins of the world:
have mercy on us.
Lamb of God, you take away the sins of the world:
have mercy on us.
Lamb of God, you take away the sins of the world:
grant us peace.

'If I have a problem or see a problem starting, I say the *Lamb of God,* so that I don't react in a negative way. I apply this prayer more to work. It is a selfish way of looking at prayer. Yes, I do believe there is a God there. If an officer is injured I depend on the *Our Father* to forgive those who trepass against us. In prison life there is so much negativity that we do need prayer, especially the inmates; they depend on prayer.'

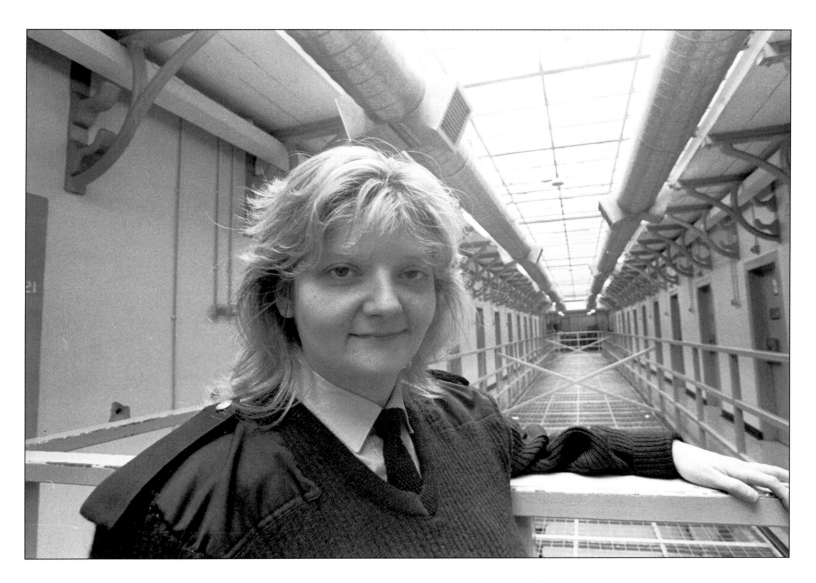

Jackie McKenna is pictured in the women's section of Mountjoy Prison, Dublin.

DERVILLA KEATING

While Dervilla Keating was serving a fifteen-month sentence in Mountjoy Prison for shoplifting, she wrote the following lines:

I say a prayer to God
To help me through the day here,
and hopefully never come back.
To survive,
and to start a new life when I'm free.
I think about my family
and about why I am here.
I look at the other women around me
and see why they are here too.

Dervilla began her sentence in May 1999 and was released in September 1999. She now lives with her parents, Annette and Michael. She has three brothers, Michael, Brendan and Ciarán, and three sisters, Valerie, Jacinta and Denise.

'Since leaving prison, I am doing very well. I would like to thank my parents and family for their great support and patience. They have been wonderful to me. I am also thrilled to be part of this book.'

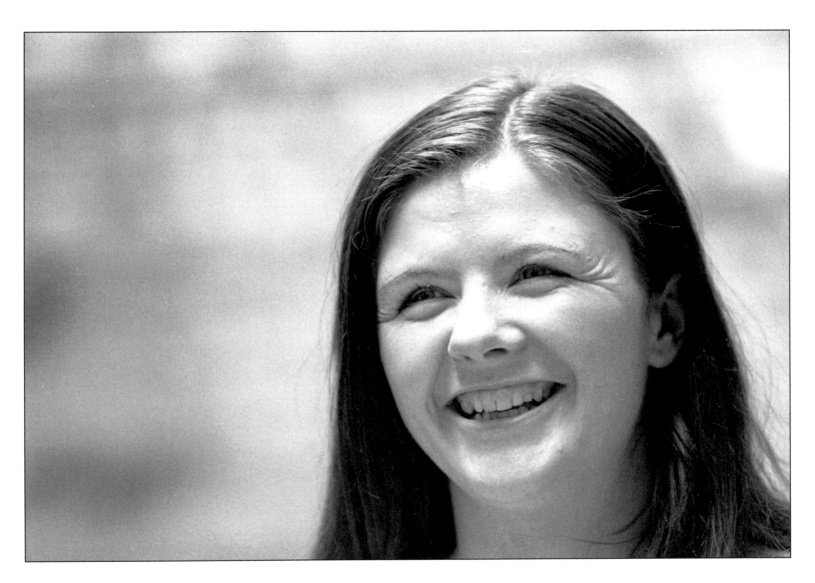

Dervilla Keating is pictured in the women's section of Mountjoy Prison, Dublin.

MARY LEONARD

Mary Leonard works part-time at Knock Shrine Friends Association, County Mayo, She is also a housewife and works with her husband Pat on the family farm in Culmore. They have five children – Paul, Laura, Lisa, Patrick and Catríona. She enjoys reading and yoga, and plays an active role in the activities of the Church in their parish.

Come Holy Spirit
fill the hearts of the faithful and
kindle in them the fire of your love.
Send forth thy spirit
and they shall be created
and you shall renew
the face of the earth.

'My favourite prayer would be to the Holy Spirit. I have a lot to be thankful to God for. I pray for sick children everywhere because of my own experience when we spent a lot of time in the hospital with our daughter. I saw the worry and anxiety of other parents. I pray for all those people who look after the sick, especially the nurses, surgeons, and physiotherapists. I pray for families who are struggling, and for young people to grow up and keep the faith.'

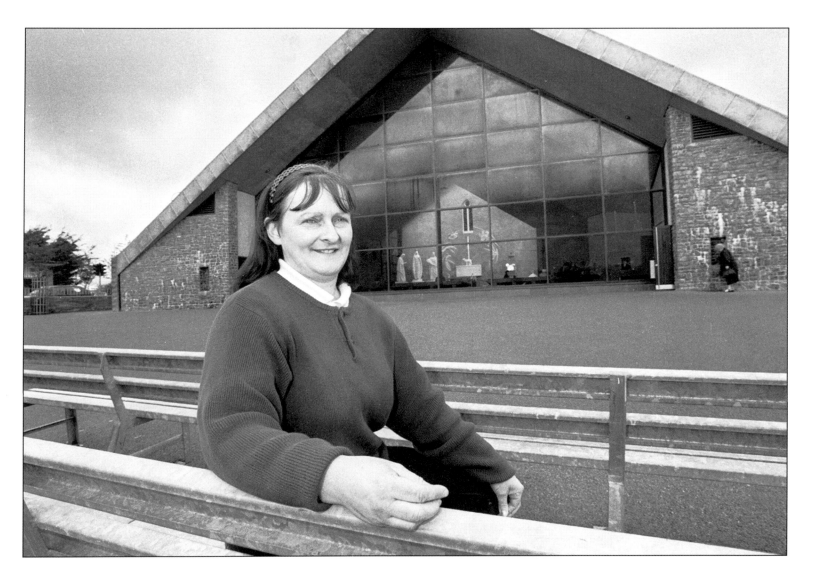

Mary Leonard taking a break from her busy schedule at Knock Shrine, County Mayo.

DARINA ALLEN

Darina Allen owns and runs the internationally renowned Ballymaloe Cookery School at Shanagarry, County Cork. She has presented the Simply Delicious *cookery series on* RTÉ *and has written nine best-selling cookbooks. Darina has featured on BBC's* Master Chefs *and on* Good Morning America. *Darina continues to develop her extensive herb, vegetable and fruit gardens around the school. While Darina still considers them a hobby, they now attracts visitors from all over the world.*

Dear Lord,
we give thee thanks for the good earth and all that comes from it
and I pray that we all have the wisdom to work with nature for
the good of mankind.

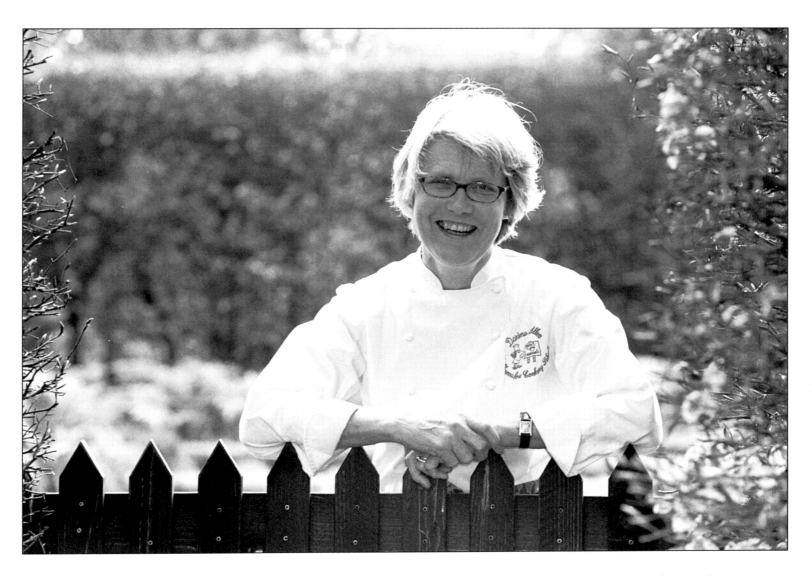

Darina Allen is pictured in her extensive herb garden at Ballymaloe Cookery School, Shanagarry, County Cork.

MARGARET KENNY

Margaret Kenny was born in Mohill, County Leitrim and educated in St Louis Secondary School and University College, Galway. She married Desmond Kenny in November 1940 and opened Kenny's Bookshop in Galway. Today it has the largest selection of books by Irish authors in the country, along with an art gallery and extensive internet service.

Dia Linn. A dhia éist linn.

O Angel of God, my guardian dear,
to whom God's love commits me hear.
Ever this day be at my side,
to light and guard, to rule and guide.
Amen.

'The prayer to the guardian angel is one that my mother instilled in me. She had a strong belief in the guardian angel. It was the first thing you thought about in the morning and the last thought of the night.'

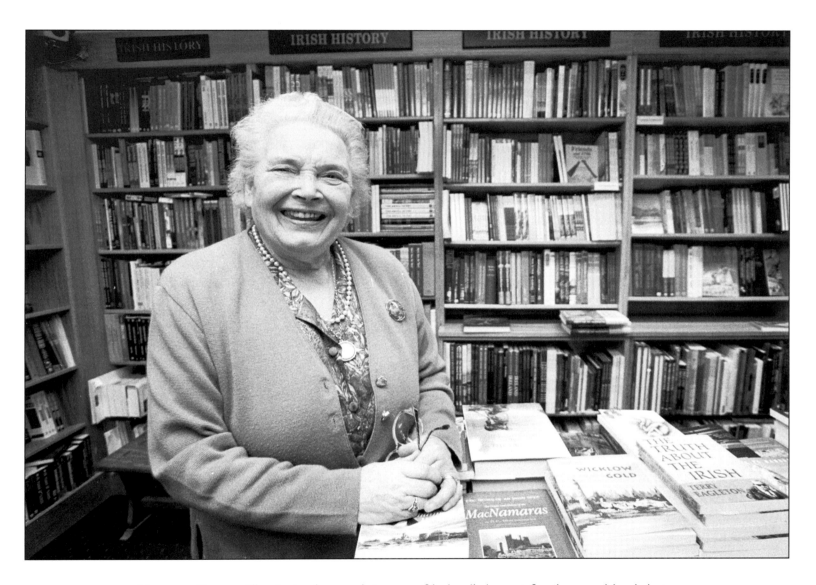

Margaret Kenny still enjoying her work in one of Ireland's largest family-owned bookshops.

ALICE TAYLOR

Alice Taylor is one of Ireland's best-loved authors. Her first and best-known book To School Through The Fields, *published by Brandon in 1988, became one of the biggest-selling books ever published in Ireland, and her sequels,* Quench the Lamp, The Village, Country Days *and* The Night before Christmas, *were also outstanding successes. Alice lives in the village of Innishannon in County Cork, in a house attached to the local supermarket and post office. Her eldest son has taken over the running of the business, which has given Alice more time to devote to her writing. Alice was born on a farm near Newmarket in County Cork, and worked as a telephonist in Killarney and Bandon. She is a popular guest on radio and television. She is married to Gabriel Murphy and they have four sons and one daughter.*

'As you awake in the morning, the few moments before your mind is completely alert is the time which tells you how in harmony you are with yourself and the world at large. Are you full of enthusiasm for the day ahead or reluctant to get out of bed? If I am not looking forward to what the day might bring I say this prayer':

Courage for the Day

This is the day that the Lord has made
and each hour will be blessed
If you ask him for the strength
To do your very best
Whatever the path to follow,
He'll be walking by your side
To be your strength and comfort
Your friend and constant guide

The Lord is understanding
His Mercy will not fail
His love for you is infinite
His goodness will prevail
Remember this each morning
And you'll not be afraid
To face with growing confidence
The Day the Lord has made.

'During my mother's final weeks of life, we said this prayer together every morning and it gave her the courage and patience to face another uncomfortable day. This made it special for me.'

'Another little thought that I read if I hit a bad patch is':

However Long At Dark

I can urge,
beloved human,
to search out your courage;
even if the bitter stone
in your chest is, you think,
forever

and you can take no more,
hold fast, hold fast;
that stone will melt,
and the tunnel will become a flow of discovery
and it will be again morning.
I have seen it.

Eithne Strong

'This was sent to me by a nun who looks after prisoners. There are different kinds of prisons in life and this could bring comfort in dark patches.'

Alice Taylor, whose simplicity of life shines through in her stories from the heart of Ireland.

ELAINE O'DONOVAN

Elaine O'Donovan is a clerical officer with the Civil Service attached to Tralee Garda Station, County Kerry. She is a member of the Friary Folk Group in Killarney. She is actively involved with the GIFT programme run by the Diocese of Kerry. Elaine has been a member and leader of the Irish Girl Guides, Killarney branch, since 1976. She enjoys swimming, walking and fishing.

The Clouds' Veil
by Liam Lawton
Even though the rain hides the stars,
Even though the mist swirls the hills,
Even when the dark clouds veil the sky,
You are by my side.

Even when the sun shall fall in sleep,
Even when at dawn the sky shall weep,
Even in the night when storms shall rise,
You are by my side.

Bright the stars at night that mirror heaven's way to you.
Bright the stars in light where dwell the saints in love and truth.
You are by my side.

Deep the feast of life where saints shall gather in deep peace
Deep in heaven's light where sorrows pass beyond death's sleep.
You are by my side.

Blest are they who sing the fellowship of saints in light.
Blest is heaven's King. All saints adore the Lord, most High
You are by my side.

'This piece of music is a gentle reminder of the spiritual side of life for me and also makes me think of the beautiful valley of Killarney, where I live, with the contrast and change of light upon the lakes, and the rise and fall of the sun bounding off the mountains. I struggle with God in many ways. I am reminded that, in our imperfect world, even a clouds' veil can have beauty and, somehow, when the veil is folded, a new day dawns and God is by my side.'

Elaine O'Donovan takes a break on her daily walk on Ross Island, Killarney.

MARY LEE-STAPLETON

Mary Lee-Stapleton is a hairstylist at Dominos in the village of Croom, County Limerick, and has been self-employed for eight years. Mary is married to Peter Stapleton and they have two children, Kaylee and Jessie. She is a native of Millstreet, County Cork. She enjoys music, cinema, reading, football and hockey.

Lord Jesus,
I give you my eyes to see as you see
my tongue to speak as you speak
my hands to do your work and
feet to walk your way,
so that, in my heart I may love
as you love
and above all Jesus
I give you my weaknesses
that you may act and work through me.

'My six-year-old daughter, Kaylee, came home from school with this prayer. It couldn't be more expressive. Seen through the eyes of a child, it's not as intense as other prayers. The simpler the prayer, the easier it is to understand and believe what you are saying. A children's God is a wonderful God.'

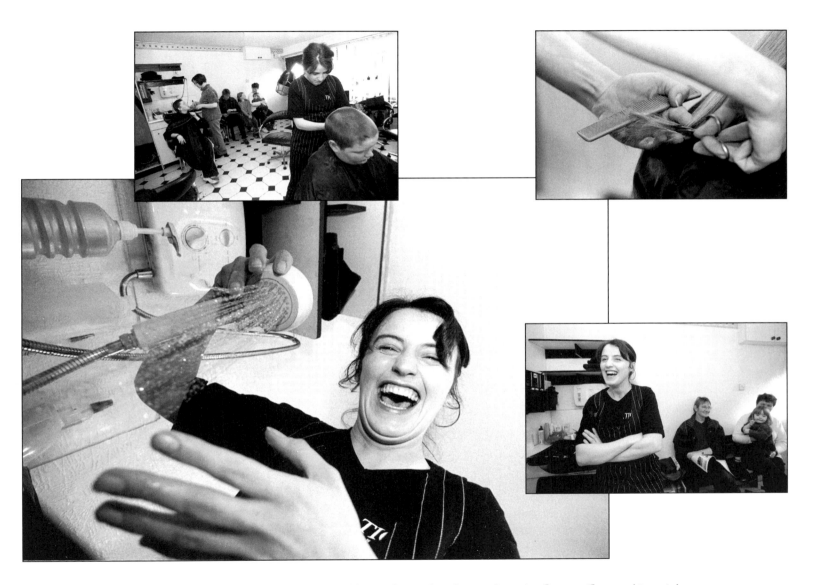

Mary Lee-Stapleton enjoying a typical busy day in her hair saloon in Croom, County Limerick.

BERNADETTE GREEVY

Bernadette Greevy is internationally recognised as one of the finest mezzo-sopranos singing today. Born in Dublin, she has sung on all five continents with many orchestras and has given innumerable recitals in most of the major world capitals. She has performed, with outstanding success, major operatic roles including Eboli in Verdi's Don Carlos, and Charlotte in Massenet's Werther. Her voice has a unique richness and depth. She is particularly renowned as a Mahler singer. Bernadette has made many great recordings during her career. She has been honoured with the Harriet Cohen International Music Award for Outstanding Artistry. She holds honorary Doctorates of music from the University of Ireland and Trinity College, Dublin. She is Artist in Residence at the Dublin Institute of Technology and Faculty of Applied Arts. Bernadette is Founder/Artistic Director of the Anna Livia International Opera Festival of which the inaugural season will take place in June 2000.

Salve Regina

Salve Regina mater misericordiae!
Vita, dulcedo et spes nostra salve.
Ad te clamamus, exsules filii Evae.
Ad te suspiramus, gementes et
flentes, in hac lacrimarum valle.
Eia ergo, advocata nostra
illos tuos misericordes oculos ad nos
converte.
Et Jesum, benedictum, fructum
ventris tui, nobis post hoc
exsilium ostende.
O clemens, o pia, o dulcis Virgo Maria.
Ora pro nobis, sancta Dei Genitrix.
Ut digni efficiamur
promissionibus Christi.

Hail Holy Queen

Hail, holy Queen, mother of mercy!
Hail our life, our sweetness and our hope.
To you we cry, poor banished children of Eve;
to you we send up our sighs,
mourning and weeping in this valley of tears.
Turn then, most gracious advocate,
your eyes of mercy towards us;
and after this our exile,
show unto us the blessed fruit
of your womb, Jesus
O clement, O loving, O sweet Virgin Mary.
Pray for us, O holy Mother of God,
that we may be made worthy
of the promises of Christ.

'I have thought quite a lot about my choice of prayer for this anthology and have decided on the beautiful salutation to Our Lady, the *Salve Regina*. I always sing this exquisite hymn in Latin. Our Lady is a wonderful force. God is God, he is a person, but a mother is such a special person, especially the mother of God. A mother is a person you go to for advice. She is your best friend and, like the Mother of God, she will never desert you. She keeps us calm, she influences us and encourages us to make amends. Like grains of sand, we can go to her.'

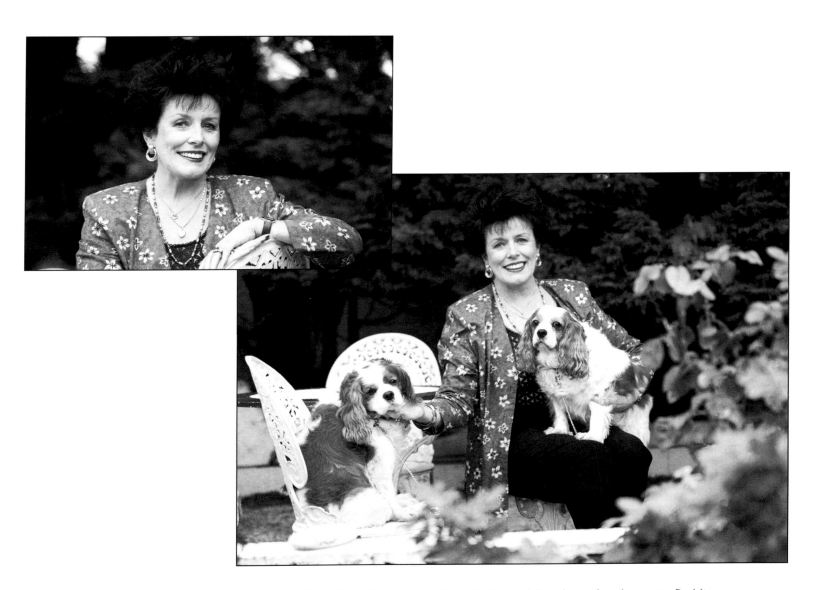

Bernadette Greevy is pictured with her King Charles Spaniels, Guido and Bambi, at her home in Dublin.

MARIE FOLEY

Marie Foley is a sculptor living in Thomastown, County Kilkenny. She is originally from Kanturk, County Cork. After studying at the Crawford College of Art and Design in Cork, the University of London and Goldsmiths College, she taught at Scoil Mhic Shuibhne in Cork. In 1997, she completed her MA degree. Since then she has had exhibitions throughout Europe. Her solo exhibition in the Irish Museum of Modern Art in Dublin was a major success. Marie is a member of the Board of Directors of Butler's Gallery, Kilkenny and in 1996 she was elected a member of Aosdana (an organisation for artists set up by the Arts Council). She is currently working on a commission for Duchas at Kilkenny Castle.

The Lord's Prayer

O thou the breath
The light of all,
Let this light create
A heart-shrine within.
And your counsel rule
'Til oneness guides all.
Your one desire then acts with ours,
As in all light,
So in all forms.
Grant what we need, each day,
In bread and insight.

Loose the cords of mistakes binding us,
As we release the strands we hold
Of others' faults.
Do not let surface things delude us.
But keep us from unripe acts.
To you belongs the ruling mind,
The life that can act and do,
The song that beautifies all,
From age to age it renews.
In faith, I will be true.

'This translation of the *Lord's Prayer,* from Syrian Aramaic, is possibly the closest existing version to the prayer that Jesus spoke. The translator, Neil Douglas-Klotz, has attempted to maintain some of the Aramaic rhythms and nuances of meaning.

I love the symbolism in this *Our Father.* It is laden with imagery much more encompassing than the traditional *Our Father.* This prayer expands into the realms of wordless thought. It helps you transcend. The word breath can mean so many things… beyond the ordinary. It gives you such insight. Those words, to "loose the cords" are a poem in themselves, a work of art. It is endless, like a meditative experience. It is the only prayer I need.'

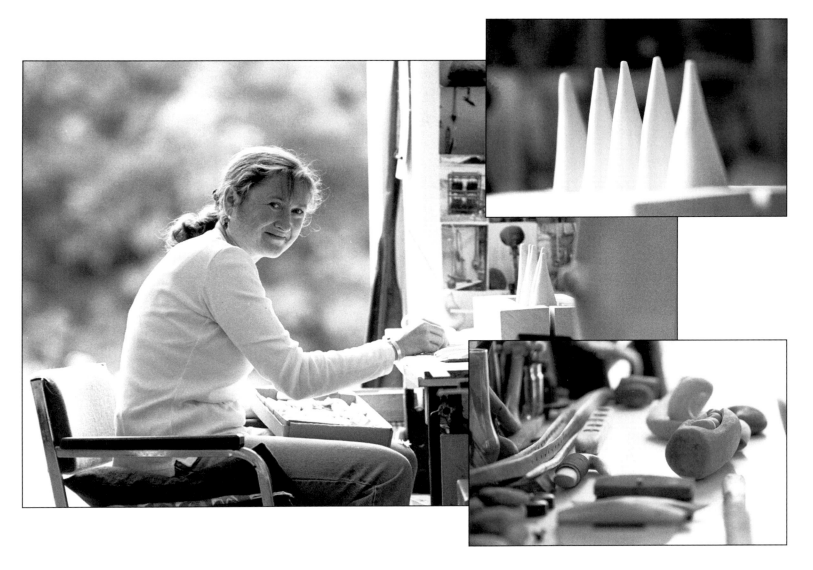

Marie Foley working on a commission for Kilkenny Castle in her studios in Carrickmore, County Kilkenny.

RUTH GILL

Ruth Gill lives and works on the family farm in Kilcormac, County Offaly. She is a diocesan lay reader at Birr Parish Church and is a member of the Church of Ireland General Synod. She is involved with a healing prayer group and with various Church activities within the parish. She is married to George Gill and they have two children, June and John.

Lord,
Your Presence fills the universe,
fills the earth. This room. My mind.
Lord, I am still
before you.

Our Father,
Hear us as we remember in the quietness of our hearts,
those who are ill in body, mind or spirit. We name them before you one by one.
You love them and know their needs far better than we do. We do not dictate to you.
All we ask is that you will do for them as you see best,
and bless them with your peace;
for the sake of our Lord Jesus Christ. Amen.

To your
Care and protection, O Lord, we now commit ourselves
Of your goodness forgive us; with your love inspire us;
by your Spirit guide us; and in your mercy keep us,
now and always. Amen.

O thou
who hast ordered this wondrous world
who knowest all things in earth and heaven,
so fill our hearts with trust in thee,
that by night and day, at all times and in all seasons,
we may without fear commit those who are dear to us
to thy never-failing love, for this life and the life to come. Amen.

'I pray for someone in trouble, someone coping with illness everyday, someone for whom nothing can be done. I ask myself "why?" then I say "Into your hands I commend their spirit". I follow that up with *The Lord's Prayer,* for things in life that I appreciate and am thankful for.'

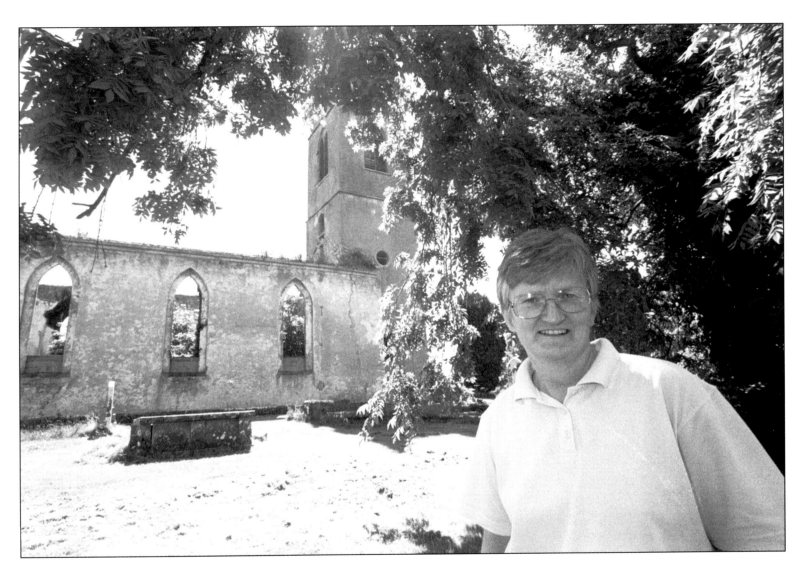

Ruth Gill is pictured at the ruins of Kilcormac Church of Ireland, which lies close to the old family farm.

BREDA JOY

Breda Joy is an award-winning journalist and the author of Brian Crowley's biography entitled Against the Odds. *Breda was named Provincial Journalist of the Year in 1997. She lives in Killarney with her son Brendan and is a member of the Killarney Mountaineering Club.*

'For all that has been, thanks, for all that will be, yes.'
(Dag Hammarskjold)

'Thursday, 24 June 1999, 3.40am, Killarney: It's a measure of the lack of space in my crowded life for a time of prayer, that I'm up at the dead hour of the night writing this piece, it must be said, weeks behind schedule. With a sore throat keeping me from sleep, I got up and switched on the computer and then went to the bookcase to take up my ancient copy of *Markings* by the author quoted above. Many of the lines I had marked years ago stood out, but the following reflection seemed particularly apt for the job at hand: "How can you expect to keep your powers of hearing when you never want to listen? That God should have time for you, you seem to take as much for granted as that you cannot have time for him." Working full-time and raising my son, aged seven, takes up so much time that prayer has been all but squeezed out of my life. The gap I find every other night is when I'm putting Brendan to bed. We begin by blessing ourselves in Irish, since he goes to Gaelscoil Faithleann. Our prayer is a simple one really, thanking God for the good things that have happened to us during our day, blessing the people who have done us a kindness and praying for those who may be in need of our prayer. I inject a bit of fun into the minute or two, when I can, by making the prayers rhyme.

The only other real time I have for prayer is at Sunday Mass in the Franciscan Friary. At its essence, prayer for me is thanksgiving for the blessings of life and, when things are tough, a search for inner peace or strength. All that being said, it is very much the prayer of unknowing, "Lord, I believe, help thou my belief". For this anthology, I returned to a more "believing" self, to another life when I was a student in Dublin and a time when there was more space for reflection. The following lines are taken from a diary page written in Drumcondra on 29 May 1981, as my years in college were finishing and my circle of friends was about to break up:'

Living within currents of giving and receiving
which flow through me and around me,
The place doesn't matter
as long as this sharing remains part of me, all of me.
My unsure hope is that these currents are eternal
And that they will support me and carry me
to that absolute giving and receiving of Father, Son and Spirit.

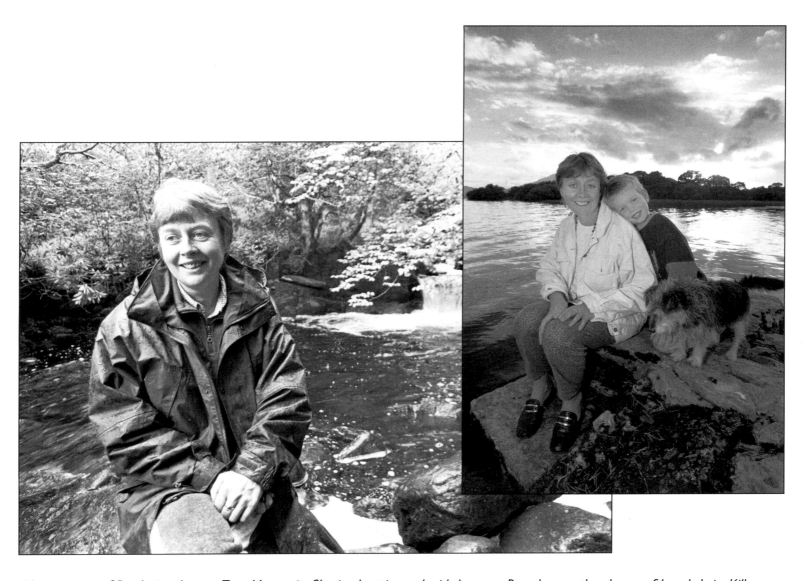

Main picture of Breda is taken on Torc Mountain. She is also pictured with her son, Brendan, on the shores of Lough Lein, Killarney.

NICOLA UNDERWOOD QUINN

Nicola Underwood-Quinn is a practicing psychotherapist in Dublin and a member of the Humanistic and Integral Psychotherapy Association and the Family Therapy of Ireland Association. Nicola conducts courses, seminars, workshops and retreats in Ireland, Europe, South Africa and the US, in the areas of spirituality, transpersonal psychology, rituals, shamanism, health and sexuality. She has been at the forefront in initiating and facilitating diverse community and personal development projects in Ireland. Nicola lives in Dublin and has two children, Síne and Malachi.

> Love is patient; love is kind; love is not envious or boastful or arrogant or rude. It does not insist on its own way; it is not irritable or resentful; it does not rejoice in wrongdoing, but rejoices in the truth. It bears all things, believes all things, hopes all things, endures all things. Love never ends.
> *I Corinthians 13:4-8*

An Ode to Life
The departed, whom we now remember, have entered into the peace of life eternal. They still live on earth in the acts of goodness they performed, and in the hearts of those of us who cherish their memories. May the beauty of their lives abide among us as a loving benediction. *This Hebrew prayer is said every day for eleven months after a loved one has departed this life.*

'I sit twice a day and let my body and mind settle and come into balance. In the morning, to be in the practice of being – being in the balance of loving, awakened, enlightened compassion for myself and others, I ask for the space to be present to each moment unfolding, and the time for the training in taming the tiger.

At night, after meditating, I have time to reflect on my day, my relatedness, if I've done harm in any way and how to make amends. Prayer for me is the voice from the heart that gives direction to the tongue. It separates the me from my perceptions and preoccupations and gives life to the way of dreams. It is a meditative experience, it comes from the place of stillness and becomes mindless, loving, awakened, enlightened compassion, to be present… it is continuous.

While in a two-year practice called "Back to the Beginnings", one of my prayers formed into action a series of seminars which I call "Into the Heart of Stillness, Silence, Surrender, and the Beat of the Heart". At its very essence it's theme can be expressed by these two quotes: "What lies behind us or what lies before us are tiny matters compared to what lies within us." (Oliver Wendell Holmes); and "Love grows when you trust the universe is at your side." (Rumi).'

Nicola Underwood-Quinn pictured at her home in Sandymount, Dublin.

EILEEN GOOD

Eileen Good worked for many years in television production in RTÉ on programmes for young people, documentaries, daytime and religious affairs and sports. Eight years ago she joined the freelance world as a producer/director. One of her projects over the past four years has been producing the videos which accompany Alive-O, the new Veritas catechetical programme for primary schools. Her interests include music, gardening, photography, travelling, trying out new recipes and good conversation. Eileen is married to Paul Good and they have three children, Emily, Pauline and James, and one grandson, Nathan Paul.

A Friendship Blessing
May you be blessed with good friends.
May you learn to be a good friend to your self.
May you be able to journey to that place in your
soul where there is great love, warmth of feeling
and forgiveness.
May this change you.
May it transfigure that which is negative, distant or cold in you.
May you be brought in to the real passion, kinship and affinity of belonging.
May you treasure your friends.
May you be good to them and may you be there
for them; may they bring you all the blessings,
challenges, truth and light that you
need for your journey.
May you never be isolated; but may you always
be in the gentle nest of belonging with your anam chara.
John O'Donoghue, from Anam Chara

'I have chosen this prayer because it sums up the value of friendship for me. I am extremely conscious of the importance of my friends. For many years I would have said I was very lucky with my friends – now I realise I am very blessed with my friends – and equally important is the inclusion of my family among those friends.'

Eileen Good takes a break from work on the post-production of the new Alive-O *series for* Veritas *in Dublin.*

AILEEN O'SULLIVAN

Aileen O'Sullivan is a resident of Kerry Cheshire Home in Killarney. A native of Ballyhea in Dingle, Aileen is twenty-seven years old and has just completed two subjects in the Leaving Certificate – English and Business Studies. She hopes to pursue a career in drama. She has already performed in a play entitled The Thorny Rose. *Aileen is an avid reader and she enjoys music, writing and socialising. She is the daughter of Patrick and Maisie O'Sullivan, and has a brother and a sister, Timothy and Niamh.*

Night Prayer

As I lay down my head to sleep,
I give my soul to God to keep.
There are four corners on my bed,
And four bright Angels over my head.
One to guard me, one to guide me,
Two to take my soul to Heaven.
God Bless Good Friday,
Friday day,
The Day our Lord was crucified,
My Jesus mercy,
Mary help.

'This prayer is in memory of my grandmother, Eileen O'Sullivan, who lived next door to me at home in Dingle. Her prayers were very dear to her and she put a lot of time and effort into teaching me this prayer when I was very young. In doing this we spent a great deal of time together. Now when I say this prayer at night I can still see the big smile on my grandmother's face when I finally knew the prayer word for word.'

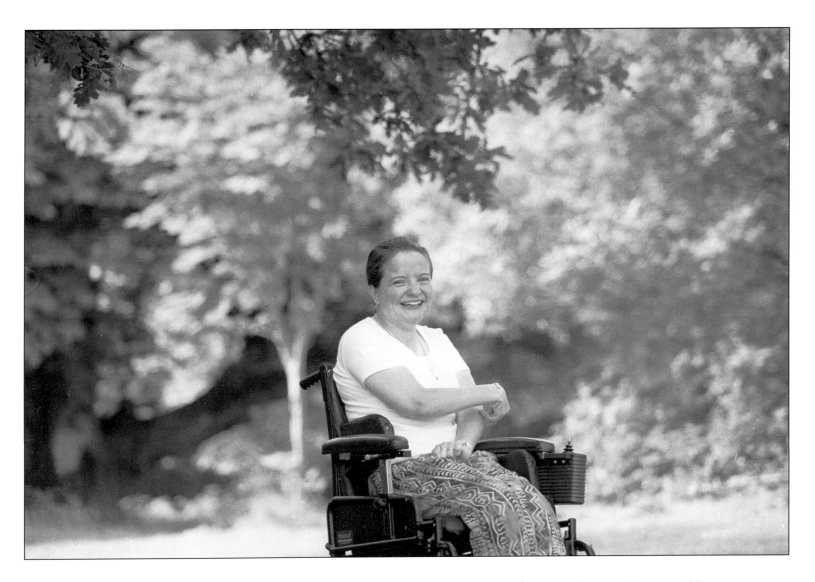

Aileen O'Sullivan enjoying the cool summer breeze in the Killarney Demesne, near her new home in Killarney.

GERALDINE LAKE

Geraldine Lake lives in Mayfield in Cork City. She describes herself as 'number one, a housewife, then a designer and inventor'. She has five children and, despite her very busy life, she graduated from University College, Cork with a diploma in social science.

Time for Me
Lift me high above the clouds
so I can drift away
just for a little while
to enjoy the beauty of today.
Let the sunshine caress my face
as my eyelids close to rest,
let my body be refueled
by my every breath.
Teach me to enjoy tranquillity
that is free,
to take a break for just a while
and take this time for me.

'I'm always such a busy person. I never have time for me. I was sitting by myself in the garden and these words just came to me as I was enjoying my little bit of sunshine.'

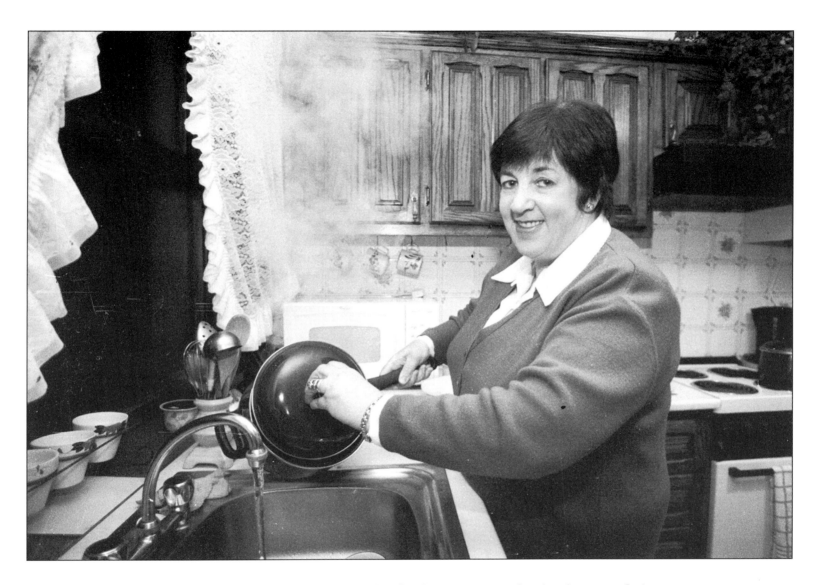

Geraldine Lake strains the vegetables for the evening meal at her home in Cork.

MARGARET HICKEY

Margaret Hickey is from Toem, Cappawhite, County Tipperary. She was employed as a line operator with Tambrands before its closure in November 1996. This closure had a devastating effect on the area, which had already experienced factory closures over the years. Margaret subsequently completed a computer course and worked with Cashel & Emly Youth Service. She is currently looking for employment.

Prayer of St Francis

Lord,
make me an instrument of your peace;
where there is hatred, let me sow love;
where there is injury, pardon;
where there is doubt, faith;
where there is despair, hope;
where there is darkness, light;
and where there is sadness, joy.
O Divine Master,
grant that I might not so much seek
to be consoled as to console,
to be understood as to understand,
to be loved as to love.
For it is in giving that we receive,
it is in pardoning that we are pardoned,
and it is in dying that we are born
to eternal life.

'I've loved this prayer since my childhood. I suppose its the simplicity of the prayer… if everyone could be like that.'

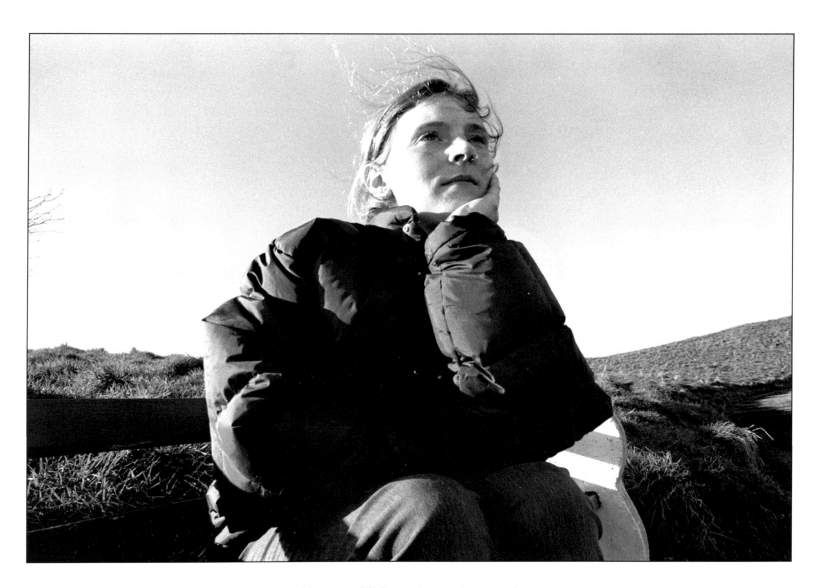

Margaret Hickey – in pensive mood.

CAROLINE MOONEY

Ensign Caroline Mooney has been with the Irish Naval Service for three years. She is presently attached to the LE Emer. Some of her duties include navigation watches and boarding fishing trawlers. She is studying science at the University of Galway.

Sailor's Prayer
Lord,
Protect me when I'm afloat or ashore.
Guard our ships and all who sail in them.
When I'm in danger, may your strength be my hope.
Let me feel your presence when I'm alone.
Keep my family and friends always in your love.
May they be there to welcome me when I return.
Amen.

'It is a prayer that is so relevant when I'm away at sea. It incorporates not only my family and friends but also the ships and the crews that sail on board them.'

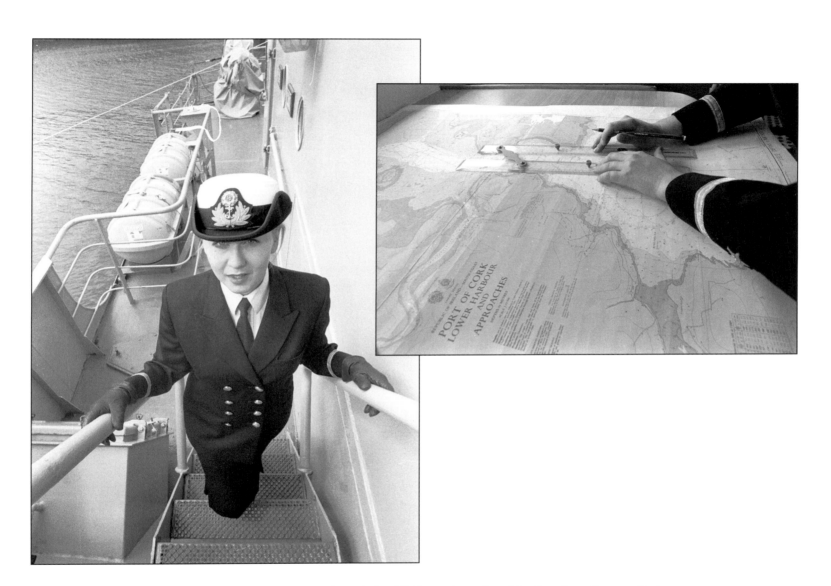

Ensign Caroline Mooney on board the LE Emer, based at Haulbowline, County Cork.

URSULA O'FARRELL

Ursula O' Farrell is a tutor and supervisor with the Tivoli Institute in Dun Laoghaire, Co. Dublin. She works also as a private counsellor and supervisor. She holds a primary degree in Economic Science, and also a Diploma in Psychology from University College, Dublin. Ursula is an accredited member of the Irish Association for Counselling and Therapy (IACT), and has served both as Cathaoirleach and as Secretary of that organisation. She is the author of the highly successful First Steps in Counselling *(1988) and* Courage to Change: The Counselling Process *(1999). She likes to garden and travel when she can. She lives in Dublin and enjoys the company of her children and grandchildren.*

> Lord, Support us all the day long,
> until the shadows lengthen,
> and the evening comes,
> and the busy world is hushed,
> and the fever of life is over,
> and our work is done.
> Then in your mercy,
> grant us a safe lodging,
> and a holy rest,
> and peace at the last.
> *John Henry Newman*

'I see this prayer as one of hope and purpose and destination. It has a simplicity and, unlike many traditional prayers, uses the original words so the meaning remains unchanged. Its cadences are measured and calm, and when I say it, I feel myself becoming quieter, breathing easier, becoming grounded in myself, laying aside the fuss and worry and fretting of my life. It focuses me, and restates what my journey is about and where I am going. It is like looking forward to arriving home on a dark, cold, wet evening, anticipating shelter, warmth, a lit fire and companionship. There is a sadness also, since I first heard it when my husband was ill, and it links back to that fearful time. And yet I can also identify this prayer with his presence, and his present whereabouts, at peace in a safe lodging.'

Ursula O'Farrell pictured at her home in Booterstown, County Dublin.

FIONA MORIARTY

Fiona Moriarty is an ophthalmologist in active practice in both the Beaumont and Mater Misericordiae hospitals in Dublin, and in Tullamore, County Offaly, her native home. Both her parents practice medicine in Tullamore. Fiona is also the ophthalmologist with the National Council for the Blind. She is a past member of the Board of Management at Gonzaga College, Dublin. Her husband, Denis Moriarty, is Professor of Anaesthesia at University College, Dublin. They have four children, John, Denis, Fiona and James. In her spare time, Fiona enjoys playing golf and tennis.

'If I were to pray,
To know what I should say
To him who sent us here
To work and play and pray,
I know full well
What I should say and do,
To try to come to you;
And first to keep the Lord's command,
to love our neighbour,
and to help the poor, to face each dawn
with hope in their hearts.
Praying that each day might bring them peace
and happiness in their home.
And so my prayer would be
for love and peace in every home,
and that every dawn would be
a little brighter than the last.'

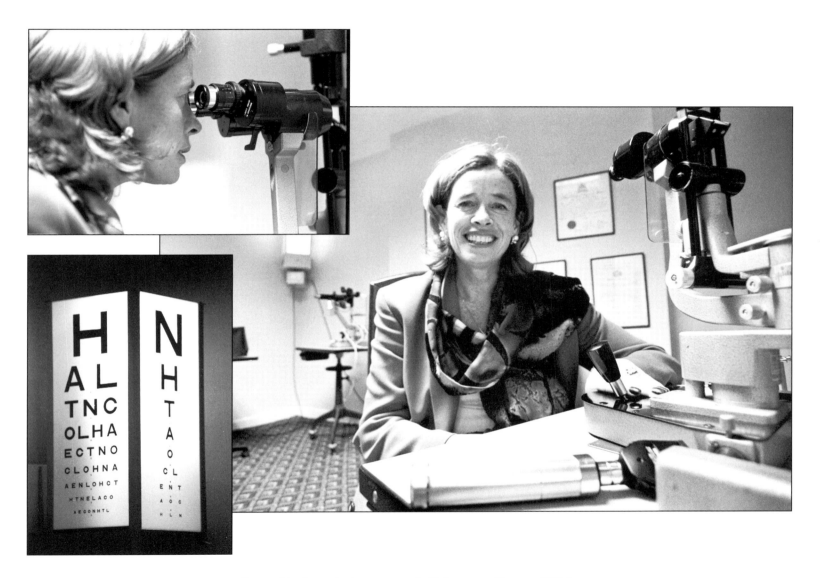

Fiona Moriarty in her rooms in Tullamore, County Offaly.

RUBY BARBER

Ruby Barber is the chairperson of the Mental Health Organisation in Birr, County Offaly. She has been involved with the organisation for over twenty years. She began her career as a midwife in Liverpool and moved on to Cheshire and then to Northern Ireland. She was a QA in the Nursing Army in Germany from 1949-1951. She married in 1951 and has five children.

> Guide us, O Lord,
> to do your will,
> and draw us nearer to you
> day by day
> For Jesus' sake.

'I say this prayer for all my family. Only two of my five children are church-goers, that but doesn't mean they are not believers. I would very much like to have a discussion group between educated believers and agnostic scientists. So many people believe what they see. How do you account for creation? I don't know! They tell me it evolves from a single cell. I believe there has to be a superior being at the back of it all. I belong to a healing group here in Birr – who can say whether it is the power of the specialist at work, or the power of God, or both?'

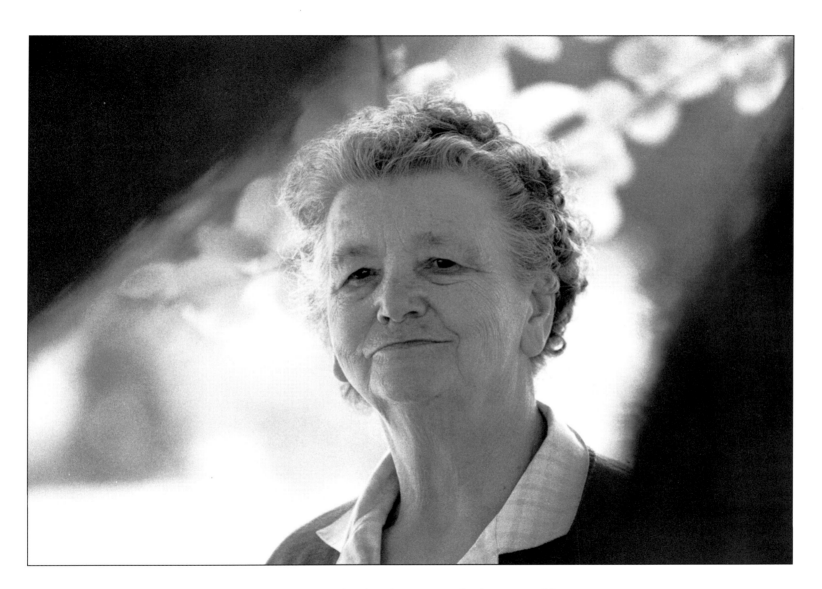

Ruby is pictured at her home outside the town of Birr.

SR THÉRÈSE MURPHY

Sr Thérèse Murphy is originally from Annaghmore, County Kerry and is a Carmelite Sister in St Joseph's Carmelite Enclosed Monastery in Malahide, County Dublin. Growing up, she was inspired by the lives of the saints, especially St Thérèse. In October 1947, she answered her calling in life and entered the Carmelite Monastery in Ranelagh, Dublin. She took her solemn vows in 1958 and moved to the monastery in Malahide in 1975. In May 1999 she celebrated her Silver Jubilee. Daily life at the monastery begins at 5.30am with Morning Prayer (lauds), followed by one hour of private prayer. At 7.30am the sisters celebrate Mass before breakfast at 8.15am. The Sisters follow the pattern of prayer in accordance with the prayer times of the Apostles – they pray seven times a day. Work and prayer are combined at the monastery. They observe a strict code of fasting from September to Easter. The Sisters keep bees, print their own cards, make candles and grow their own vegetables.

'Lord take me from the tumult of things, take me from myself and give me to yourself.'

'The following prayers were composed by Fr Pat Collins CM and were given to us at a most inspiring retreat at the monastery in July. I trust many will find them helpful as they take time to be alone with him who loves us. "May He grant you to be strengthened with might through his spirit in the inner self" (Eph. 3:16).'

Daily Prayer to the Holy Spirit
Morning
Relax your body…
Calm your mind and imagination…
Affirm that God is present…
Ponder these words from scripture…
Be filled with the Spirit,
Be guided by the Spirit,
Walk by the Spirit.

Prayer for Guidance
Father in Heaven,
Yours is a Spirit of truth and love. Pour that same Holy Spirit into my body, my mind and my soul. Preserve me this day from all illusions and false inspirations, and reveal your presence, your word and your will to me in a way I can understand.
I thank you that you will do this,
while giving me the ability to respond,
through Jesus Christ our Lord. Amen.
(pause for a moment of reflection)

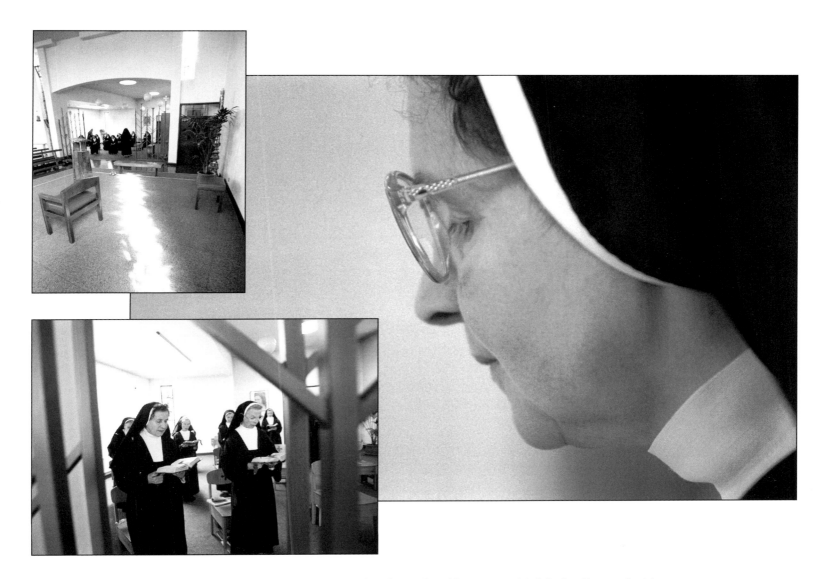

Sr Thérèse Murphy at Vespers in the Carmelite Monastery, Malahide, County Dublin.

Night
Relax your body…
Calm your mind and imagination…
Affirm that God is present…
Consider these words…
'God's presence is not discerned at the time when it is upon us, but afterwards when we look back upon what is gone and over.' *(Cardinal Newman)*

Prayer for Discernment
Father in Heaven; help me to recall with gratitude those occasions when I was aware of your presence today and to savour again what you meant to me…
(pause for a moment of reflection)

Help me to become aware of the promptings and inspirations you have given me today and to know whether I responded to them or not…
(pause for a moment of reflection)

Enlighten my heart to recognise any unloving mood, attitude, desire, or action that saddened your Holy Spirit today.
(pause for a moment of reflection)

Final Prayer
Father in Heaven; thank you for the gift of your Spirit. Today, it has urged me to see you more clearly, to love you more dearly, and to follow you more nearly. As for my shortcomings, please forgive them, and now, bless me as I sleep, so that, refreshed by your Spirit, I may rise to praise you, through Jesus Christ our Lord. Amen.
permissu Ordinarii Dioc, Dublinen

'Prayer is very simple and very personal. The important thing for me is standing before God attentively and surrendering to him in trust. Trying to go through life with my hand in the hand of God. I am always asking God to strengthen my faith and trust and to know that he is giving himself to me at every minute. St Thérèse said "prayer is a friendly love relationship". I try to conserve all my energy for God.

I have seen that his goodness and love are limitless, and that his love is a great power, striving to come to birth all over the world. I think there is a lot of evidence of this in the world – the very fact that this book is being done. There is no limit to God's divine side, it is only limited by our readiness to receive it.'

It is my greatest hope and desire that, as we move into the millennium, every baptised person may co-operate with God's merciful love. This is what Jesus came for, he calls us to live with him in close communion with the Father. He has revealed to us so much about God in Scripture. Through our Scripture sharing, we get to know something of this God before whom we now pray and try to surrender ourselves in trust.

There is the saint and the sinner in all of us – that evil cannot be rooted out. It has to be healed and redeemed.

Finding evil in ourselves we get to know ourselves – an abyss of weakness and misery trusting in God's merciful love. I suppose it is really in understanding evil that we can forgive and find forgiveness. If we know ourselves we have compassion for the weaknesses of others.'

A life of work and prayer

EDEL SUTTON

Edel Sutton is a librarian with Laois County Council. She is also a member of the renowned Carlow Cathedral Choir. Born in Dublin, she married Des and subsequently moved to Ballyroan, where they live with their children, Claire and David. Edel enjoys her association with the choir and composer Liam Lawton, who has greatly enhanced the life of Church choral music in Ireland. She is a strong supporter of alternative medicine and has an enormous interest in the local history of County Laois.

The Present (Anon)

Imagine there is a bank that credits your account each morning with 86,400 pounds. It carries over no balance from day to day. Each evening the bank deletes whatever part of the balance you failed to use during the day. What would you do? Draw out every penny, of course!!!!

Each of us has such a bank. Its name is TIME. Every morning, it credits you with 86,400 seconds. Each night it writes off, as lost, whatever of this you failed to invest to good purpose. It carries over no balance. It allows no overdraft. Each day it opens a new account for you. Each night it burns the remains of the day. If you fail to use the day's deposits, the loss is yours. There is no going back. There is no drawing against the 'tomorrow'. You must live in the present on today's deposits. Invest it so as to get from it the utmost in health, happiness, and success! The clock is running.

Make the most of today.
To realise the value of ONE YEAR, ask a student who failed end of year exams.
To realise the value of ONE MONTH, ask a mother who gave birth to a premature baby.
To realise the value of ONE HOUR, ask the lovers who are waiting to meet.
To realise the value of ONE MINUTE, ask a person who missed the train.
To realise the value of ONE SECOND, ask a person who just avoided an accident.
To realise the value of ONE MILLISECOND, ask the person who won a silver medal in the Olympics.
Treasure every moment that you have! And treasure it more because you shared it with someone special, special enough to spend your time. And remember that time waits for no one. Yesterday is history. Tomorrow is a mystery. Today is a gift. That's why it's called the present!!

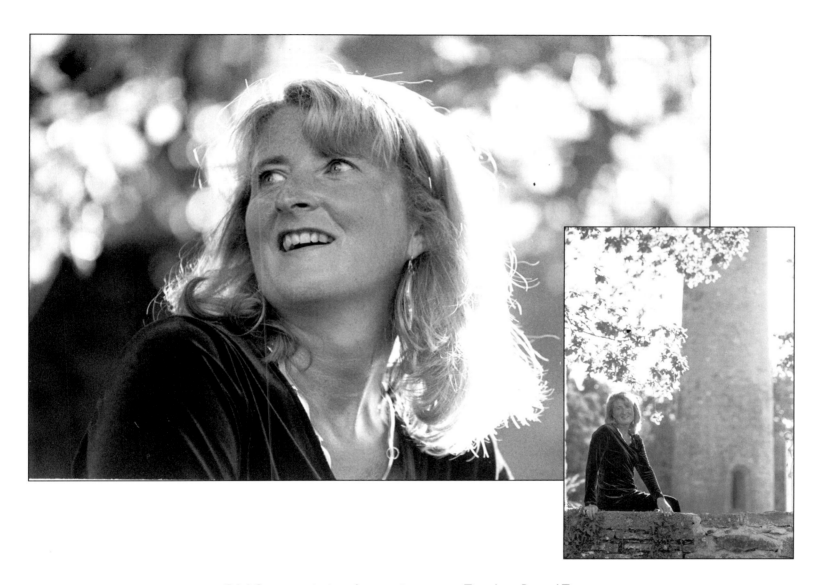

Edel Sutton enjoying the evening sun at Timahoe Round Tower.

PADRAIGÍN CLANCY

Padraigín Clancy is a graduate in Irish folklore and has recently completed post-graduate study with the Department of Irish Folklore, University College, Dublin. Over the past decade Padraigín has lectured and facilitated seminars and retreats countrywide on Irish folklore and Celtic spirituality. She has appeared regularly on RTÉ radio and television and TnaG.

She is the editor of Celtic Threads: Exploring the Wisdom of our Heritage *(Veritas 1999) – a collection of essays from various well-known personalities and scholars on Celtic spirituality. A native of Dublin, she spent several years living in Árainn (Inis Mór, Aran Islands), where she made an extensive collection of island folklore. She is a keen tin-whistle player and is a member of Comhaltas Ceoltóirí Éireann.*

'A prayer I love to use when working with groups is 'Paidir Coigilt na Tine'. This is a prayer customarily recited in Ireland by the woman of the house when banking-up the fire at night. It is quite widely found throughout the country and I received my version from my island friend and neighbour, Nan Ellen Hernon of Corrúch, Árainn, who died 5 July 1999 (go ndeana Dia grasta uirthi.) This prayer appeals to me because the hearth-fire represents the life of the home, family and community. It also represents the Holy Spirit and the feminine principle. The words of this prayer invoke the protection of Brigit and Mary – the two main female archetypes in Celtic spirituality.'

Traditional prayer for banking-up the fire at night
Coiglím an tine seo mar a choigil Críost cách,
Muire máthair an tí agus Bríd ina lár
An ceathrar aingeal is áirde, igCathair na nGrást,
Ag cumhdach an tí seo anocht is go brách.

(Keep in this fire as Christ keeps us all in,
Mary Mother of the house and Brigit at its centre
The four highest angels in the city of God
Be protecting this house tonight and forever.)

'I'm a daily Mass-goer and I find consolation in the Eucharist and the community of daily Mass-goers wherever I am – be it on the streets of my native Dublin or on the island of Árainn, my second home. Other than that, when in Dublin, I like nothing better than making a trip into Clarendon Street Church in the footsteps of my grandmother for some quiet time, and to light candles at the various statues, especially to Our Lady of Good Counsel (for wisdom and inspiration).'

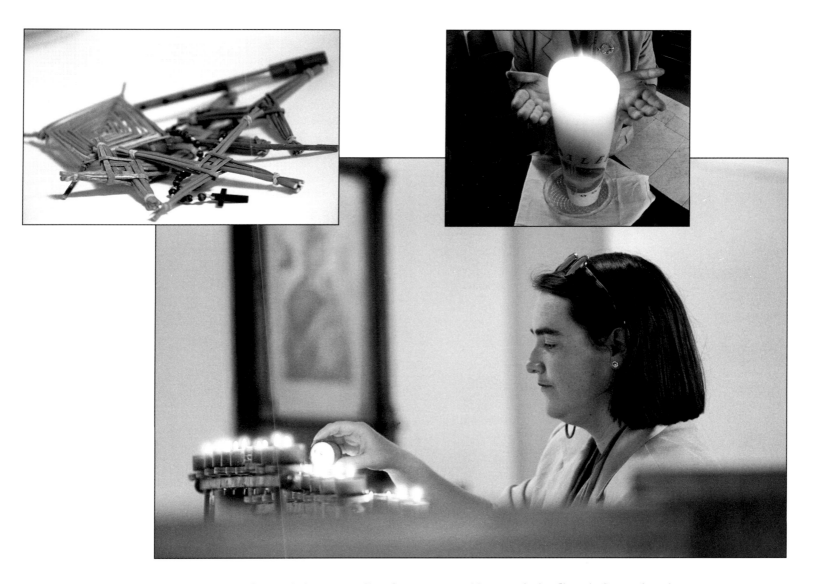

Folklorist Padraigín Clancy lights a candle after morning Mass at Avila Church, Donnybrook.

BRIDGET DELANEY

Bridget Delaney, a traveller, lives with her husband James and their ten children at Gas House Lane Car Park, Tipperary Town. A courageous and dedicated woman, Bridget is involved with the Rural Travellers Training Project, where she learned to read and write. She particularly enjoyed the health and development studies there. She was one of many travelling women who painted a mural for the National Traveller Women's Forum in Dublin. She also enjoys gardening.

The Lord's Prayer
Our Father who art in Heaven,
hallowed be thy name.
Thy Kingdom come; thy will be done
On earth as it is in heaven.
Give us this day our daily bread;
and forgive us our trepasses
as we forgive those who trespass against us;
and lead us not into temptation
but deliver us from evil.
Amen.

'Myself and the children pray the Rosary, then we say our own prayers… I Confess, *Hail Mary, Angel of God.* I pray for the Holy Souls and then I say the *Our Father.'*

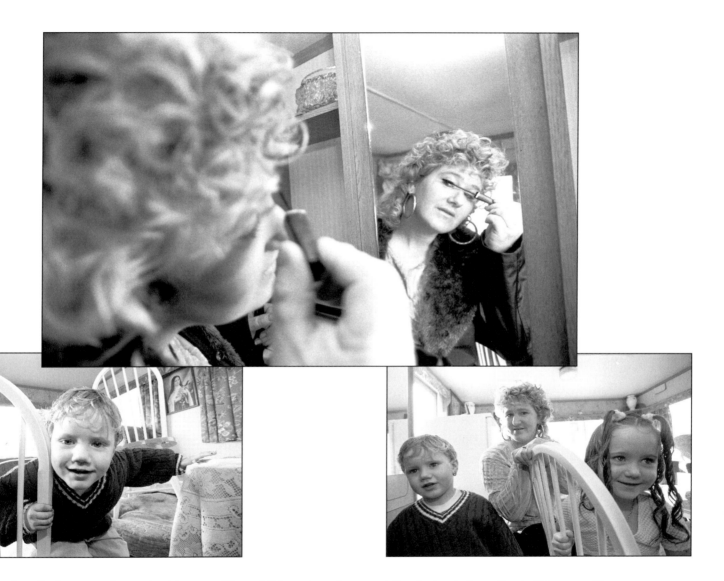

Bridget Delaney is pictured with two of her children, Jonathon and Breda, in their trailer in Tipperary Town.

MOTHER AGNES GRIFFIN AND SISTER JOHN FRANCIS WATSON

Mother Agnes Griffin is Abbess at the Poor Clare convent in Carlow. Originally from Cahir, County Tipperary, she entered the enclosed order in 1940, at the age of eighteen. She had made up her mind that this was the life to lead and the life she loved and continues to love.

Sister John Francis Watson, originally from Tipperary, was a sister of St Clare's Order, where she was a teacher, before she entered the Poor Clares in 1968.

Life in the Poor Clare convent, and in any enclosed order, is one of continuous prayer. Their whole life is centred around prayer. They receive an average of forty letters a day from people from all walks of life. Each letter and request for prayer is answered individually by the Sisters. People call to them seeking their advice and help – often in desperate circumstances. The Poor Clares offer a glimmer of hope to these people. There is perpetual Adoration in the convent. The Sisters take turns praying to the Blessed Sacrament at all times – day and night. Life in the enclosed order is frugal for the fourteen sisters, they rely on alms for survival and grow their own vegetables. They listen to the headlines of the One O'Clock News, *watch a video on special occasions and read the various religious newspapers and magazines.*

Tuning in to God

'The Spirit helps us in our weakness. For when we cannot choose words in order to pray properly, the Spirit himself expresses our plan in a way that could never be put into words.' (Romans 8:26)

'Prayer is simply a tuning into the right station – knowing where to find God and being there with him. It is both a silent listening and looking, with love and surrender. All our communion with the Lord takes place in the inner recesses of our unique self: where we think and feel and desire – "the God enlightened space" as Pope John Paul calls it. When one has experienced this "being with God", one knows instinctively that we can never 'be' without him. The Spirit of Jesus within us (the wonderful heritage of every baptised person) enables us to pray as a child to its father, while Jesus himself intercedes for us at the right hand of God. So we are assured that the Father's response will always be most generous, as he looks upon his beloved Son in whom he is always well pleased.

At the Last Supper, Jesus told us clearly that it is only through him that anyone can draw on the grace of God. Without him, not only are we powerless, we wither and die like a broken branch. We can't do ourselves or anybody else good at all by our own efforts.

Being with God in this way – contemplation is another word for it – does not prevent us putting the needs of others before him; rather it encourages us. But we do not tell him what must be done. We

simply state the need, totally confident that he will look after each one with all his love – the way his mother Mary prayed for the young married couple at the wedding in Cana: 'They have no wine'; and the way Martha and Mary prayed for their brother Lazarus: 'This one you love is sick'.

In prayer, it is God's will that is of paramount importance, not what we want. Our total union with God and his divine will gives the power to our prayer, because our pleas "expressed by the Spirit, are according to the mind of God" as St Paul reminds us in Romans 8:27.

Our whole life of communion with the Lord is one for the whole Body of Christ, the Church, to the benefit of all, no one excluded. There are no boundaries to the distance prayer can travel – it is limited neither by time nor space. The power of technology, marvellous as it is, has its limits: internet, e-mail, computerisation – anything can go wrong, mistakes are made, they are powerless unless one has a computer to start with. But every baptised person is endowed with the ability to enter into communication with God – indeed, every human being possesses it as an intelligent creature made in the image and likeness of God. Furthermore, no matter how zealous we are in reaching out to others in their need – perhaps as a teacher, nurse, social worker – we can only reach a limited number of people: but prayer is limitless.

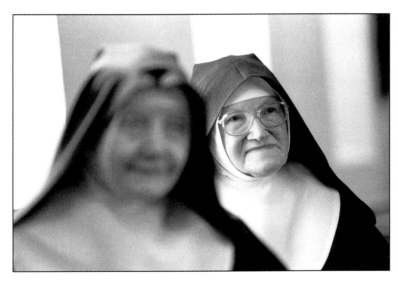

Mother Agnes Griffin

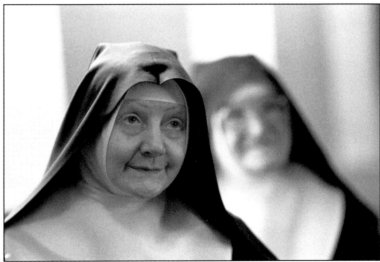

Sister John Francis Watson

'Prayer is the only way to bring all to God. When we have experienced a longing to bring all to God, we won't be happy with just a few. We may never know, in this life, how many our prayer has touched – we don't need to. We simply stay "plugged in" to the only source of power for good, knowing in the depths of our hearts that as the all-powerful God draws us into closer union with himself, we automatically grow in union with all humankind. The words *Our Father* immediately suggest that every man and woman on planet earth is my brother and sister – and what implications that has on today's world! Every Poor Clare experiences this growth in awareness of how our life of prayer touches all lives; one joins in the sufferings and joys of others: 'When one part of the body suffers, all suffer with it…' and the converse is true, too (1 Cor. 12).

One can feel so powerless in the face of evil, injustices, tragedy, cruelty – it could overcome us if we were not "plugged in" to the source of all goodness and power and wisdom. Realising the poverty of our human nature on its own is a humbling and salutary experience: it is balanced by the precious gift of faith, encouraging us to tune in more clearly to the one who alone is good, to allow the Spirit to pray in us for all God's people. What a tremendous gift we have been given! The greatest thing we can do for others is to pray for them, to place them before the face of the Father as a poor brother or sister of his only Son, the Beloved, and to allow the torrent of his all-powerful, all-wise love to renew them as he wills. Individuals, families, countries – the whole world of need is our apostolate now: let us pray!

And let us bring all before the Father not only in their need, but as our companions in worship and praise and thanksgiving and loving surrender. Let us always "tune in" on this note at the start of our prayer and at the end, because adoration is the very purpose of our being.

Yes, we can search the internet and look into the unknown. But it is limited and does not satisfy our craving. Searching the internet of God's love and mercy, on the other hand, is limitless and eternal. The website is PRAYER: once tuned in we are operational!'

A Prayer
With loving trust and humility we come to you, most merciful Father. We acknowledge our deep dependence on you as we bow down in worshipful adoration. We thank you for your loving care and providence in watching over us since you created us and in redeeming us through the passion of your beloved Son, as well as for the enlightenment we receive daily from the Holy Spirit.
Amen.

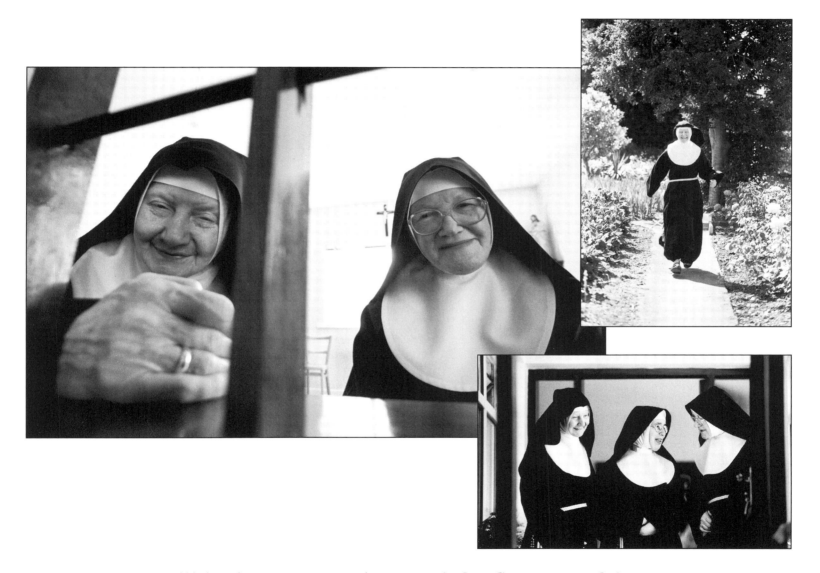

Work and prayer is a continual process at the Poor Clare convent in Carlow.

LORNA SIGGINS

Lorna Siggins is the Marine and Western Correspondent with The Irish Times. *Now based in Galway, Lorna has covered various international events during her time as a reporter in* The Irish Times *newsroom. She is the author of* Everest Calling *and* The Woman Who Took Power in the Park, *both published by Mainstream. She lives with her son Cian in Salthill.*

For someone in trouble somewhere.

'I have no religious persuasions but I suppose this is often my recurring thought when I am in trouble myself. I remember in particular a small girl who took my hand when I was in a transit camp in Somalia during the height of the famine in 1992. I looked down at this curly head of hair, and then she turned her face up and it was half-eaten away by some sort of infestation. I have never forgotten her and I wonder where she is or did she survive at all.'

Lorna and Cian Siggins enjoying a breezy walk along Galway Bay.

BREDA MARNANE

Breda Marnane is post mistress at Bansha Post Office, a job she took over from her mother in November 1983. She is married to Patsy Marnane who also works in the post office. Bansha was one of the first places in Ireland to get electricity, in 1947, under a voluntary pilot scheme, and it came to the shops in the town first. In this way, Bansha Post Office was the first rural office to be electrified. It was also the first to be computerised.

Holy Mother of God
watch over us,
protect us, keep us safe from all harm.
Amen.

'I find that I can say it without thinking… it covers everything – if my family are away from home or in trouble. I say it basically when anybody needs it, which is quite often.'

Breda Marnane, post mistress of Bansha Post Office, County Tipperary.

KATHLEEN MAHON

Kathleen Mahon and her husband, Tom, have carved out their living from the sea and the land at Kinvara, County Galway, for seventy-five years. They gathered carrageen moss and seaweed at Trá na Gaoithe which they sold to the local factories and enterprises, and also carried out some mixed farming. They are now retired and are enjoying the fruits of their labour. Both Tom and Kathleen are avid bridge players and they also enjoy spending time with their grandchildren.

De Profundis
Out of the depths have I Cried to Thee O Lord;
Lord hear my voice.
O let Thine ears consider well:
the voice of my supplication.
If Thou, O Lord, wilt mark iniquities: Lord, who
shall abide it?
For Thee there is merciful forgiveness: and
because of Thy law I have waited for Thee, O Lord.
My soul hath hoped in the Lord.
From the morning, watch even until night: and with him
is plenteous redemption.
and he shall redeem Israel: from all his iniquities.
 Psalm 129

'I say this prayer for guidance out of the depths of my own heart. And of course we pray the Rosary every day – that's one prayer we never miss.'

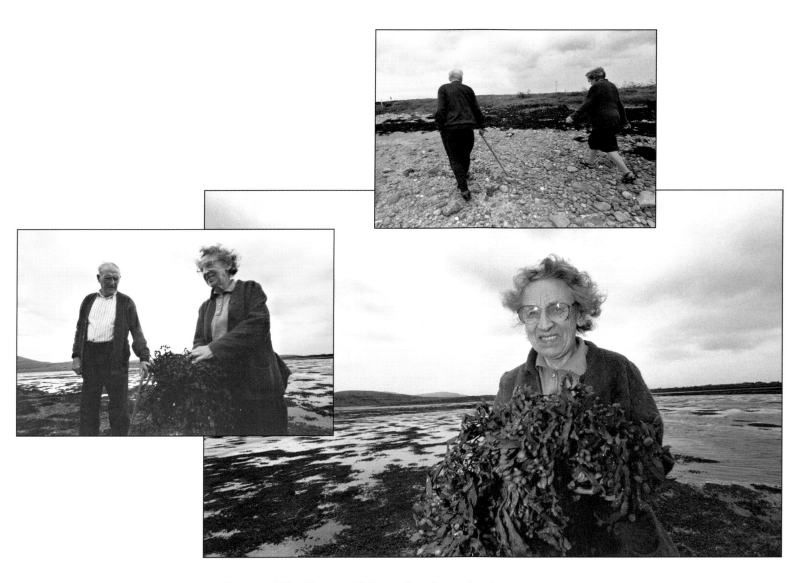

Tom and Kathleen on Trá na Gaoithe, collecting carrageen.

NUALA NÍ DHOMHNAILL

Nuala Ní Dhomhnaill was born in St Helen's, Lancashire in 1952, of Irish-speaking parents, and was brought up in the Dingle Gaeltacht and in Nenagh, County Tipperary. She was educated at University College, Cork, where she became involved with the 'Innti' schools of poets. Nuala has lived in Holland and Turkey, where she taught English at the Middle East Technical University. In 1980 she returned to the Dingle Gaeltacht to write full-time. A regular broadcaster on radio and television, she was the first Artist in Residence in University College, Cork, and was recently the Writer in Residence with Dun Laoghaire/Rathdown County Council. Nuala is also a member of AOSDANA, Poetry Ireland and IWU. Her poetry collections include An Dealg Droighin *(1981),* Feis *(1991)* Céad Aighnis *(1998) and the recently published* The Waterhouse *(1999). She won the Irish American Foundation O'Shaughnessy award in 1988 and the Gulbenkian Foundation, New Horizon's Bursary in 1995. She is married with four children and lives in Cabinteely, County Dublin.*

Comraí Dé ar an domhan is a mháthair,
Comraí na Maighdine ar mo cháirde is mo naímhde.

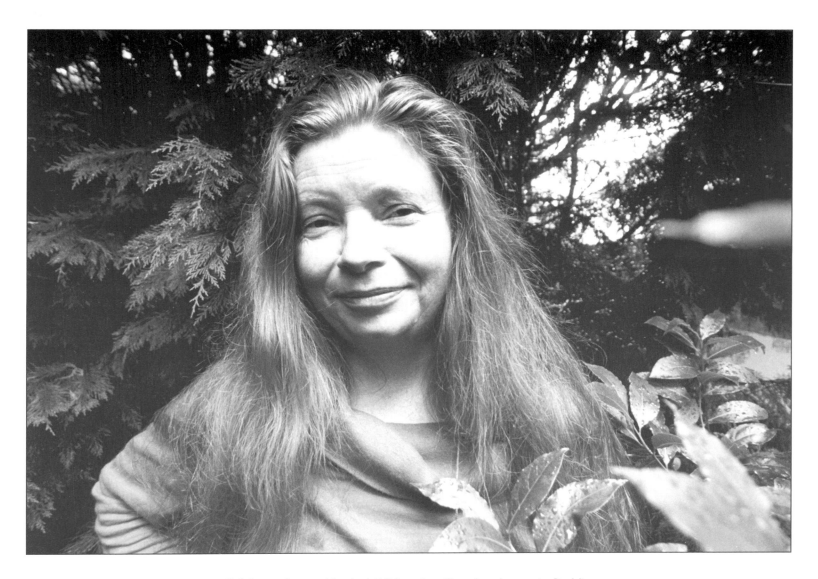

Celebrated poet Nuala Ní Dhomhnaill at her home in Dublin.

GERALDINE BYRNE

Geraldine Byrne has been the principal at St Joseph's National School, Tullamore, for nine years. She has been teaching at the school since 1974. St Joseph's is a junior mixed school with a language class and three classes for children with moderate degrees of learning disabilities. Geraldine is originally from Tyrrellspass, County Westmeath, and is married with two children. She describes herself as an avid reader.

Who can separate his faith from his actions,
Or his belief from his occupations?
Who can spread his hours before him, saying,
'This for God and this for myself;
This for my soul and this other for my body?'
All your hours are wings that beat through space
from self to self…
Your daily life is your temple and your religion.
Whenever you enter into it take with you your all.
Take the plough and the forge and the mallet and the lute,
The things you have fashioned in necessity or for delight.
For in reverie you cannot rise above your
achievements nor fall lower than your failures.
And take with you all men.
For in adoration you cannot fly higher than their
hopes nor humble yourself lower than their despair.
And if you would know God, be not therefore a solver of riddles.
Rather look about you and you shall see him
playing with your children.
And look into space; you shall see him walking
in the cloud, outstretching his arms in the lightning
and descending in rain.
You shall see Him smiling in flowers, then
rising and waving his hands in trees.

'I have chosen this from *The Prophet* by Kahlil Gibran because, when it is hard to pray, it is nice to feel that God is part of everything in life.'

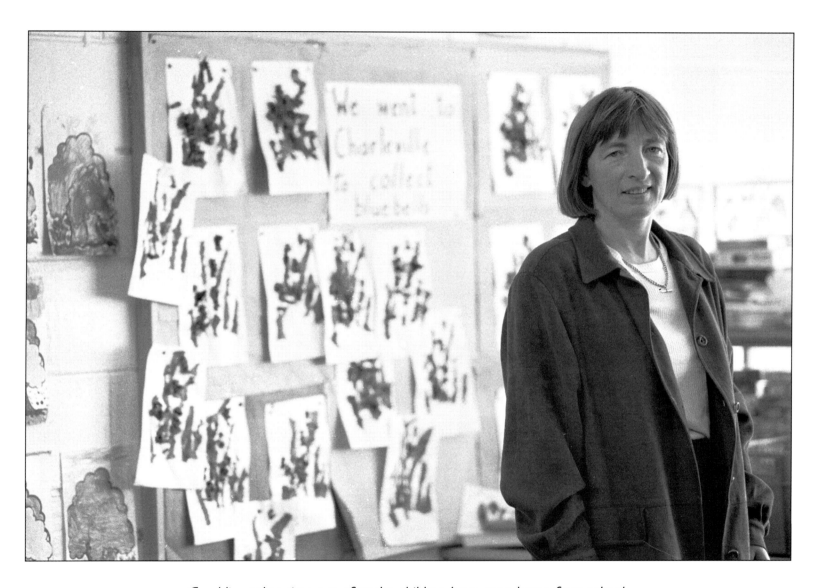

Geraldine takes time out after the children have gone home from school.

ANGELA WHITE

Angela White is a retired farmer, busy mother, grandmother and great-grandmother. She is a member of the Widows' Association in Cappa, and enjoys making dolls for the local fairs.

Dear Jesus and Mary,
thank you for the many blessings
I have received during my life,
especially my children, grandchildren
and great-grandchildren...
Keep them safe,
keep them close to you.
Help them make the right
choices in life and be happy.

'Because I love talking, I say a lot more when I pray to God. I can't say the Rosary like that. I say *The Angelus* twice a day. I ask God for different things in life... I just talk away and that's the way I pray.'

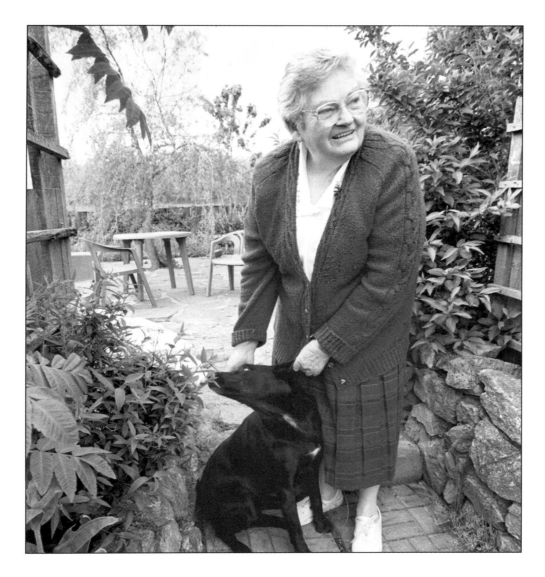

Angela White brings her dog for a morning walk in Cappa, County Tipperary.

JUDY GREENE

Judy Greene is a potter, with a studio and three retail shops in Galway. Judy is orginally from Claddagh in Galway, and began her craft twenty-five years ago. She is the president of the Chamber of Commerce in Galway City. She is married to Paul Fox who also works with her in the business. They sell their pottery throughout the country and run a very successful world-wide mail order service. They have two sons, Brian and Andrei. Judy enjoys reading, swimming and walking.

'When I look at a place like Kosovo or Bosnia and look beyond the ethnic head-dress, I see a child's face and think "that could be one of my sons". I look closer at the faces and think "that is someone's son or mother". When I see suffering in this life I pray that we are not blinded by colour and creed and that we can look at our own families and then try to see each of those suffering individuals also as precious members of someone's family. If we all looked at people in this way all the wars and suffering would stop.'

Potter Judy Greene working in her studios in Galway.

VALERIE JONES

Valerie Jones is the Diocesan Communications Officer for the Diocese of Dublin and Glendalough Church of Ireland. She compiles the diocese's various magazines and church reviews and she is also press officer for the Archbishop of Dublin, the Rev. Dr Walton Empy. Valerie is married to Stuart Jones. They live in Templeogue and have two children, Heather and Mark, both students. Valerie enjoys playing tennis and badminton, as well as photography, travel, gardening, jazz and choral music.

'In my work as Diocesan Communications Officer the pace can become a bit frenetic at times. When I feel a bit frayed around the edges I try to take time out by meditating on the passage:

> Be still and know that I am God. (Psalm 46:10)

'That helps to restore my equilibrium and puts things back into perspective. I'm one of those delightful people who is better at night than in the morning. I'm a bit of a morning grouch. Recently I came across this piece in the Bible:

> Fill us each morning with your constant love that we may sing and be glad all our life.
> (Psalm 90:14)

'Somehow when I remember these words I find it easier to get out of bed without being so bad-tempered!'

Valerie Jones in her office in Templeogue.

THE NUALAS

The Nualas, described as sassy, rural babes, originated in Claremorris, County Mayo. They began performing in April 1995, touring Ireland with their mixture of sketches and songs about tractor pile-ups, Donald Sutherland and greasy chippers. They have been nominated for best-scripted comedy series at the British Comedy Awards and are currently working on a new television project with Channel 4. The trio includes Susan Collins from Dublin, Suzannah Dewrizon from County Limerick and Anne Gildea from Sligo.

Thank you, God,
for our gifts and talents.
We do not take our greatness
for granted.

The Nualas… back to their roots in Claremorris!

CLAIRE TROY

Claire Troy is a second-year student at Our Lady's Bower Secondary School, Athlone. Her hobbies include basketball, swimming, and football. She is a team member of the Bower Buzzer Basketball Team and hopes some day to become as talented as her hero Michael Jordan. Claire hopes to study law and would like to become a barrister. She lives in Athlone with her parents and three brothers.

The Difference
I got up early one morning
and rushed right into the day;
I had so much to accomplish
that I didn't have time to pray.
Problems just tumbled about me,
and heavier came each task.
'Why doesn't God help me?'
I wondered.
He answered, 'You didn't ask'.
I wanted to see joy and beauty,
but the day toiled on, grey and bleak;
I wondered why God didn't show me.
He said, 'But you didn't seek'.
I tried to come into God's presence;
I used all my keys at the lock.
God gently and lovingly chided,
'My child, you didn't knock'.
I woke early this morning,
and paused before entering the day;
I had so much to accomplish,
that I had to take time to pray.
 Author unknown

'I came upon this prayer while visiting a liturgical centre. This prayer means a lot to me. It shows how some people are often too busy to say one prayer of thanks for what they have, and they just expect everything to go well, and it shows the difference one prayer can make in our everyday lives.'

Claire Troy revising for her summer exams at Our Lady's Bower, Athlone, County Westmeath.

ADI ROCHE

Adi Roche is the founder and executive director of the Chernobyl Children's project, which was founded in 1990, in response to the suffering caused by the fallout from the Chernobyl nuclear disaster in April 1986. A native of Clonmel, County Tipperary, Adi worked with Aer Lingus before leaving to work as a volunteer with the Irish Campaign for Nuclear Disarmament in 1982. The Chernobyl Children's project operates a total of fourteen programmes in Belarus, Western Russia and the Ukraine. So far it has delivered £12,000,000 worth of humanitarian aid including life-saving operations for children in need. Adi Roche is also on the Board of Directors of the Radiological Protection Institute of Ireland.

The Deer's Cry

I arise today
Through the strength of Heaven
Light of Sun
Radiance of moon
Splendour of fire
Speed of lightning
Swiftness of wind
Depth of the sea
Stability of earth
Firmness of rock.
I arise today
Through God's strength to pilot me
God's eye to look before me
God's wisdom to guide me
God's shield to protect me
From all who shall wish me ill
Afar and anear
Alone and in a multitude
against every cruel
Merciless power
that may oppose my body and soul.
Christ with me, Christ before me,
Christ behind me, Christ in me.
Christ beneath me, Christ above me,
Christ on my right, Christ on my left.
Christ when I lie down, Christ when I sit down
Christ when I arise, Christ to shield me.
Christ in the heart of everyone who thinks of me.
Christ in the mouth of everyone who speaks of me.
I arise today.

Anonymous

'What an inspiration! Whether I read this prayer or hear it sung, it has an instant effect. It soothes, heals and fortifies my spirit. It enables me to transform from weakness to strength, from despair to hope, from being alone to being in union. In some of the saddest times, it evokes inner peace and light and helps me rekindle joy and tranquillity. Whenever I feel overwhelmed by the magnitude of the world's problems I recite *The Deer's Cry* and it gives me courage. I put on God's loving armour and move forward with confidence and reassurance for God's sake, for the planet's sake, for children's sake.'

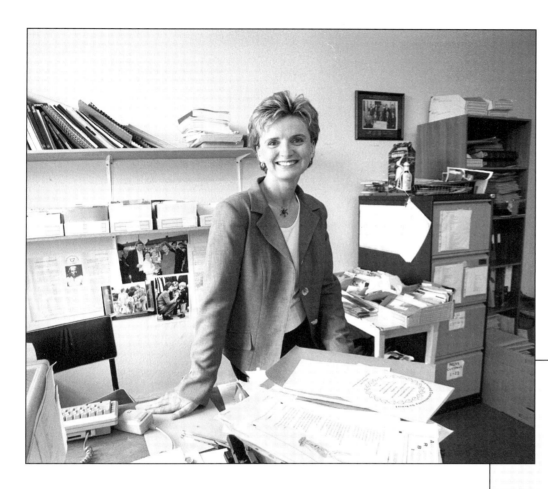

Adi Roche working in her offices in Camden Quay, Cork.

PATRICIA DARLING

Patricia Darling was born in County Down, into a clerical family. She is married to Edward Darling, Bishop of Limerick and Killaloe. She is a mother of five, a grandmother, and a former teacher. She and her husband have lived in Limerick since 1985.

'When I pray, the words I use are obviously conditioned by current situations and circumstances — sorrow or joy in my family, in the community, or in the wider world. There is, however, one prayer that my husband and I have been praying together every night since we were married in August 1958. It is really a thanksgiving prayer while, at the same time, asks God's blessing on our marriage and ourselves. For each of us it has become very much our prayer. Obviously, when one or other of us happens to be away from home overnight, we say this prayer on our own. It has become an essential part of our lives.'

> O God our Father,
> we thank you for uniting our lives
> and for giving us to each other in the fulfilment of love.
> Watch over us at all times,
> guide us and protect us,
> and give us faith and patience,
> that, as we hold each other's hand in yours,
> we may draw strength from you and from each other;
> through Jesus Christ our Lord. Amen.

Patricia Darling gives a welcome to all visitors in her home in Limerick.

MAUREEN DILLON-O'ROURKE

Maureen Dillon-O'Rourke teaches in St Brigid's Secondary School, Killarney, County Kerry. A native of Limerick, she moved to Killarney to teach English, Religion and German in 1986. Maureen was actively involved in a number of parish programmes and worked with young people in a voluntary capacity. She is married to Jack O'Rourke and they have two children, Benjamin and Jonathon. Maureen enjoys hill-walking, travelling and the music of the '50s and '60s.

> Lord,
> Remind me regularly of the brevity of this LIFE
> That I may live each day as if it was my last.
> I'm grateful to you for my family, help me
> to really appreciate them and teach my children,
> by example, that LIFE, LOVE and HEALTH are YOUR
> precious gifts to us –
> and the only values worth fighting for.
> Amen.

'Whilst I wasn't ever really into traditional prayers, I had mega-arguments with my God – I tended to 'pray' for favours, I made requests, I plea-bargained shamelessly. Whenever my 'prayers' weren't answered I gave out to God – ranted, raved, felt disappointed and abandoned. But in February 1999 my brother (and best friend) died of a terminal illness. In fact I gave birth to my son thirty-five minutes before he breathed his last. These two events altered my entire understanding of living. Although painful to watch, it was both an honour and a privilege to accompany Ken on his death-journey. Here was a young man who was aware that his life was slowly ebbing away and yet he woke up each morning saying "we got through another night". It was he who taught me the value and meaning of life. Hence my new Daily Utterance to the Godhead.'

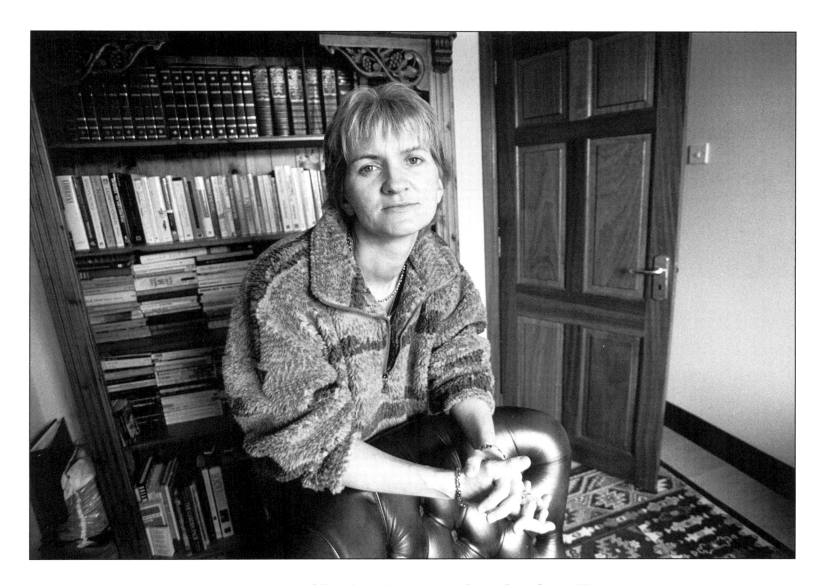

Maureen Dillon-O'Rourke at her home in Farranfore, County Kerry.

NEASA O'RIORDAN

Neasa O'Riordan is the proprietor of Poco Loco, a Mexican restaurant on Parliament Street, in the Temple Bar area of Dublin. She set up her thriving restaurant eight years ago at the age of twenty-five. Prior to that she worked in computers.

Calves on their first day of release from the shed,
big fluffy towels,
hot salsa and chips,
sweet people eating in the restaurant,
Marcheeba 'over and over' again,
people who take in my stray pets,
planes that are delayed when you're running late,
Glenveagh and midgey hoods,
beautiful beaches empty of people,
the Grand Canyon,
bees, daffodils and oak trees,
blue-bells in the woods,
stormy days, open fires, giggles with friends,
spontaneous days of fun and frolics,
hair dye,
clean clothes after farming,
carpenters, power tools.
The Cat Laughs Festival, Kilkenny.

'If you sit back and take stock of life around you, you should be thankful for the little things you have. It is these little things we completely take for granted.'

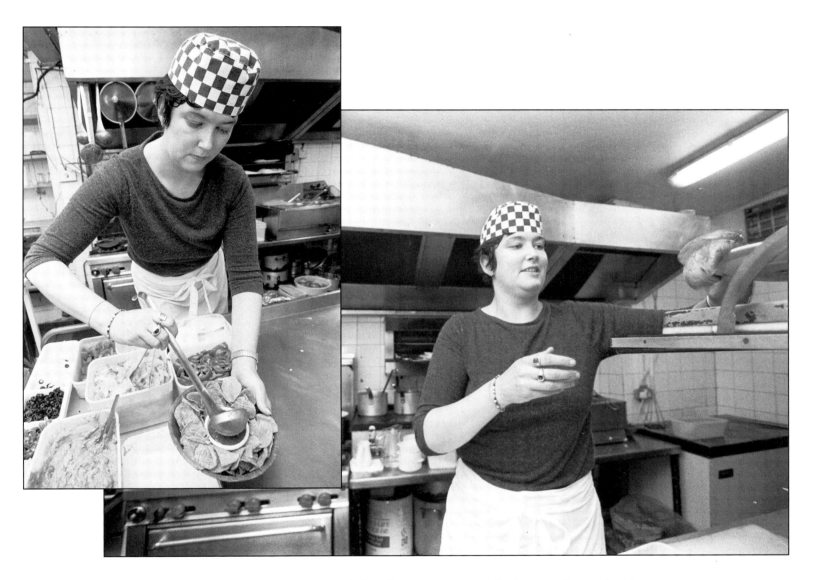

Neasa prepares a Mexican dish in her restaurant in Parliament Street, Dublin

GERALDINE HURLEY

Geraldine Hurley is a full-time performer with Siamsa Tíre, The National Folk Theatre based in Tralee, County Kerry where she is the leading female vocalist as well as an accomplished dancer, She also teaches music to students at the theatre. Siamsa's regular performances include An Goban Saor, Sean agus Nua *and* Clann Lir. *Geraldine is also a member of St John's Gregorian Choir. She is married to Oliver Hurley, dance master at Siamsa Tíre. They have two children, Cliona and Niamh.*

Please God be there for me in my time of need
and I'll try not to forget you. Thank you.

'Seven days without prayer makes one weak… and then I say my own thing suitable to the moment.'

Geraldine Hurley preparing for one of the nightly performances at Siamsa Tíre, Tralee, County Kerry.

TERESA McMORROW

Teresa McMorrow has been an electrician with the ESB since 1979, and is involved in the day-to-day electrical repairs, connections and new developments in the Castlebar area. A native of Leitrim, Teresa is married to Michael, who is also an electrician. They have four children, Irene, Gill, Chloë and Erica. Teresa enjoys walking and the company of people.

Inventory
Four be the things I am wiser to know:
Idleness, sorrow, a friend, a foe.
Four be the things I'd been better without:
Love, curiosity, freckles, and doubt.
Three be the things I shall never attain:
Envy, content, and sufficient champagne.
Three be the things I shall have till I die:
Laughter and hope and sock in the eye.

'I like this little poem by Dorothy Parker for a few reasons. It says so much in so few words and I think it expresses a realistic view on life. The poem is taken from Niall MacMonagle's *Real Cool,* given to me by my good friends David and Bonnie MacMonagle. Michael, my husband, once suggested it might well have been written about me. I never asked but I presume he meant the freckles.'

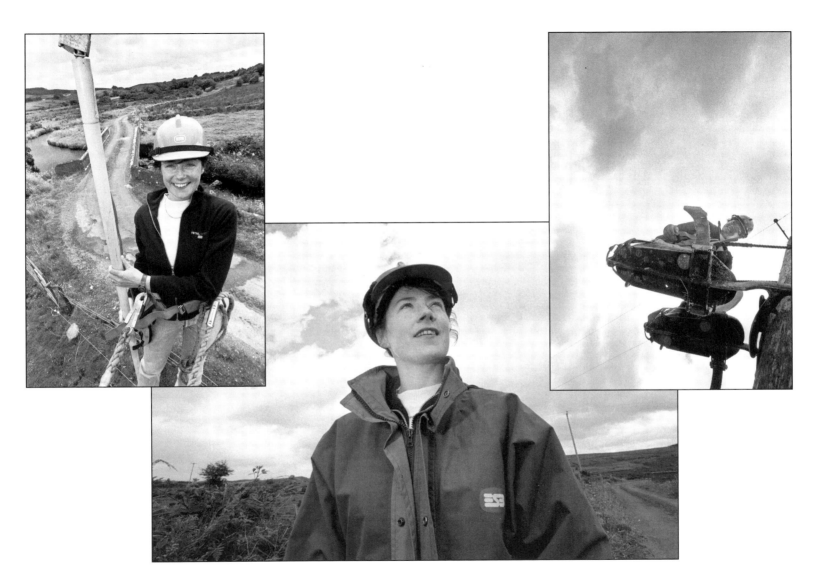

Teresa McMorrow repairing an electrical fault in County Mayo.

SR THÉRÈSE LARKIN

Originally from County Wexford, Thérèse Larkin is a Loreto Sister in Youghal, County Cork. She teaches geography and maths in the adjoining secondary school and is involved in retreats and spiritual direction workshops.

You Held Me
You held me and there were no words
and there was no time and you held me
and there was only wanting and
being held and being filled with wanting
and I was nothing but letting go
and being held
and there were no words and there
needed to be no words
and there was no terror, only stillness
and I was wanting nothing and
it was fullness and it was like aching for God
and it was touch and warmth and
darkness and no time and no words and we flowed
and I was given up to the dark and
in the darkness I was not lost
and the wanting was like fullness
and I could hardly hold it I was held and
you were dark and warm and without time and
without words and you held me.

'I was given this prayer at a time when I was struggling to describe the indescribable – an experience of God. I think that the style it is written in expresses well what the words try to describe. Having had a glimpse of this love (which is a total gift) nothing less seems to satisfy the heart, the soul. It knows what it is longing for.

My personal motto, chosen at final vows, is "In God, I'm at peace", but often in the chaos of daily living this peace eludes me. I spend my time racing around looking for what I must sit still to find! And so the contractions continue… I go on searching for the One whom I have already found. I continue to seek "him who my heart loves" (Song of Songs 3:2).'

Sr Thérèse reflects on her day on the old beach in Youghal, County Cork.

ROBERTA McKEOWN

Robbie McKeown is the mother of three grown-up children. She works as a practice manager in her husband's architectural practice in Belfast. Robbie has roots in all four provinces of Ireland and has lived in Derry, Belfast and Killarney. She values the many diverse friendships she has made over the years. Her interests include travel, genealogy, quilting and gardening.

'Give Peace, Compassion, Tolerance and Happiness to those around me and to those farther away.'

Robbie McKeown walks her dog Megan in the grounds of Stormont Castle every morning.

LORAINE DEVLIN

Loraine Devlin is a youth worker, originally from Derry. She came to Belfast to study geology at Queen's University, Belfast. She has worked as an outdoor pursuits instructor with many youth groups from Belfast city and as a volunteer co-ordinator with a European Youth Exchange programme. These experiences provided a solid base to successfully achieve a post-graduate diploma in community youth work from Maynooth College in 1995. For the past three years Loraine has worked as a community development worker with Barnardo's – on a project called Young Parent's Network. This provides much-needed support and programmes for young people who are parents and who live in West Belfast.

When people asked, I told them a lie,
Through hidden tears and a false smile,
But in the dead of night while my child lay asleep
Scared and alone I would silently weep
The tears I cried would soak my chest
No-one must know, I had to be the best
Later I learnt not to be so proud
Ask for help, it is there to be found.
Karen McHugh

'This poem was written by a young parent who lives in a rural area, but the issues that she faces are much the same for young parents everywhere. The reason I have chosen this as a thought is that it reflects the stresses that young parents experience – indeed, that any parent can face – in the extremely challenging job of raising children. It also makes me think of the low self-esteem that young people experience because of the judgements and the attitudes we hold in our society towards them, especially those who are parents. Young parents feel that they have to prove themselves, to be seen by their community as coping and to prove to others as well as themselves that they are "super parents" in order to overcome the stigma. And yet to ask for help should be encouraged, not seen as as sign of weakness. There is no such thing as "a perfect parent" but rather "a good enough parent", caring for and loving your child, as many young parents do.'

Loraine Devlin is pictured in the children's playground in the grounds of Stormont Castle, Belfast and with her friend, Roberta McKeown.

FRANCES LYNCH

Frances Lynch is a garda at Sligo Garda Station. A native Irish speaker from Spiddal, County Galway, Frances graduated from Templemore Training College in 1999. Frances was recently awarded The Templemore Urban District Council Medal for outstanding achievement in the area of social science studies.

Paidir Oíche
O Dhia, a athair, molaim thu
as ucht do chineailtain dom inniú,
as ucht mo mhuintire molaim thú
as an ngrá a thug tú dom,
I ndorchadas na noíche cosain mé
Solas na maidne go bhfeica mé
Aimaean

'Seo Paidir dheas a d'fhoghlaim mé sa scoil náisiúnta sa Spideal agus d'fhan si go hur i mo chuimhne ó shin i leith. Deirim í gach oíche agus mé ag dul a chodladh mar thug Día slán mé ó chortúirti an lae agus impim air mé a chosaint i rith na hoíche.'

Garda Frances Lynch stationed at Sligo Garda Station after finishing her duties for the day.

MARY McKENNA

Mary McKenna is regarded as Ireland's finest sportswoman, with a career in golf spanning over thirty years. She was ten years old when she won her first international competition in 1968. She has won the Irish Close Competition eight times. At international and world level, Mary captained the Great Britain and Ireland team at the European Team Championships in 1986, 1990 and 1992. She has been a team member of the prestigious Curtis Cup Team for nine consecutive years as well as British Stroke Play Champion, and Captain of the Great Britain and Ireland Team at the World Team Championships in 1970, 1974, 1976 and 1980. A native of Dublin, Mary McKenna is the sports and social manager with the Bank of Ireland, Dublin.

Dearest Lord Jesus, teach me to be generous
To give and not to count the cost
To fight and not to heed the wounds
To toil and not to seek for rest
To labour and not to seek reward
Save that of knowing that I do Thy will.

'It is the first prayer that comes to mind for me, a prayer that I learnt at a very early age. There is a lot of depth and great feeling to the words … a calmness that creates a sense of stillness in me. It is such a thoughtful prayer, one that I feel I could live by."

The legendary Mary McKenna practising in Monkstown Golf Club, County Dublin.

NÓIRÍN NÍ RIAIN

Nóirín Ní Riain is an acclaimed international singer of songs from many spiritual traditions. Her compilations include Stóir Amhrán, Im Bim Baboró and Gregorian Chant Experience. Her music is wild and sensuous and her mission is to sing and share her conviction. As a child she was deeply influenced by the Gregorian Chant sung by the Monks of Glenstal Abbey in Limerick. She is currently doing a post-graduate course in theology and is the current Artist in Residence with Laois County Council. She is married to Mícheál Ó Suilleabháin and they have two sons, Eoin and Michael, both in their teens. Nóirín is an avid tennis player. She has a great love for animals and she owns two donkeys, a Tibetan goat, a peacock, a guinea fowl and sixteen hens, not to mention the dog and cat. She lives in Newport, County Tipperary.

'Images of the soul and heart, wholeness, beauty, truth and strength all emerge in my dream of the sustaining God of the universe.

My prayer to you – and me – for the remaining days of our lives is one, not just for these gifts for ourselves, but also for a constant abiding presence in our journey – of God's hand, ear, guiding footstep and heart-song. Add to this some little prayerlets which have helped me greatly through thick and thin over the years: 'thy will be done' from the prayer directly from the Christian tradition which firmly puts us in our place as to who's in charge! *Salve Regina,* a fourteenth-century salutation to Mary, which begins one of the most enchanting hymns of the same name from the Gregorian tradition; St Francis' motto or mantra *Pax et bonum* – Peace and Goodness, sung in praise to the highest by mystic and twelfth-century Benedictine Abbess Hildegaard von Bingen, and finally, my own oft-repeated mantra, humbly borrowed and adapted from the old tax collector's prayer in Luke's Gospel: "God, be merciful to me, a sinner!" (18:13).

As I listened for the following prayer to find its way onto paper, it took on a life and shape of its own – a cross shape – as it fell onto the page. The cross – symbol of opposites: darkness and light, death and resurrection, sadness and joy – is the emblem of Brigid, goddess and Christian saint. A fitting wise woman to lead us safely in and through the third millennium!'

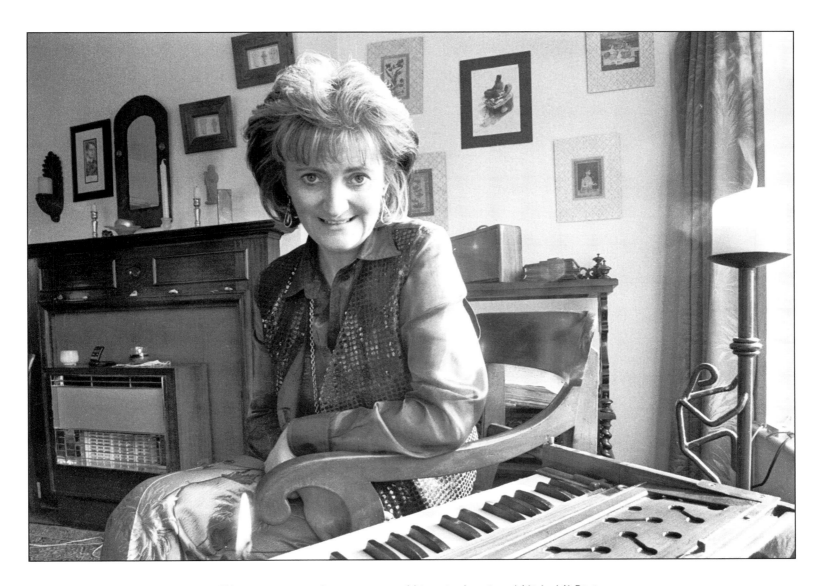

'May every note be a prayer…' Liturgical artiste Nóirín Ní Riain.

Creator God
Make me beauty
Gaurdian God
Guard me in truth
Father God
Make me strong
Mother God
Make me whole.
God's hand to hold me – God's ear to hear me
God's footsteps to lead me – God's song to fill me
Thy will be done
Salve Regina
Pax et bonum
Now let praise be
to the highest
Kyrie Eleison
God be merciful
to me a singer!

'With certainty and truth, which is the original meaning of the Hebrew word, Amen, I take my leave of you in this book of women's prayers.'

Amen.